JUNE WAYNE
THE DJUNA SET

FRESNO ART MUSEUM
MAY 3 through AUGUST 4, 1988

JUNE WAYNE: THE DJUNA SET
Copyright © 1988
FRESNO ART MUSEUM
2233 North First Street
Fresno, California 93703

FIRST EDITION

ISBN 0-932325-23-8

Designed by David Salanitro, Fresno Art Museum. All type set in Helvetica and Times Roman by Doris Hall. The catalogue was printed on Vintage Text and Cover by ValPrint in an edition of 2500.

Photography by Lawrence Reynolds, Los Angeles, California except VERDICT (fig. 2) by E. Z. Smith, Fresno, California and cover photo by Kenna Love, Los Angeles, California.

CONTENTS

ACKNOWLEDGEMENT

ROBERT BARRETT
Director/chief curator
Fresno Art Museum

This publication was made possible through the generous support of numerous people and organizations. The Fresno Art Museum's Council of 100 provided the initial funding. The Council, under the able leadership of Trustee Virginia Farquhar, was formed to honor a distinguished American woman artist on an annual basis. June Wayne was the Council's unanimous choice to be the recipient of the first award, thereby setting the highest standard for all future honorees. This year's award consists of an exhibition and this catalogue, with essays by writers of the artist's choice.

The Ledler Foundation contributed significantly to the project, as did the museum's Women's League and numerous private donors who wish to remain anonymous.

The superb essays were written by Pat Gilmore, Arlene Raven and Bernard Kester. Trustee Jane Cleave and staff member Mary Phillips assisted with proofreading the manuscript.

David Salanitro, the museum's designer, conceived the layout for this book. Ed Hamilton, June Wayne's master printer, provided the necessary specifications regarding the artwork. Hank Plone helped with a myriad of tasks, large and small.

We have been honored by playing a part in sharing June Wayne's profoundly important work. The enthusiasm of everyone associated with this project is based on our conviction that June Wayne is one of America's most distinguished artists.

CONVERSATION WITH THE ARTIST

Transcribed and edited for this catalogue from a dialogue between June Wayne and Robert Barrett in February 1988. Robert Barrett's remarks appear in *italics.*

How did the theme of space enter your work?

Around 1947, space came in as the "camel's nose under the tent flap," as one of a cluster of elements that I was trying to blend into a piece of actual time within the picture plane. The way Proust wrote, changing his characters from one time frame to another, intrigued me. I wanted a visual equivalent, to be able to state a theme in a painting and move it through the space of the picture plane, changing it as it went. Viewing the painting would use a piece of "real" time. It was a kind of cinematic idea.

By 1950 I was interested in atomic structure, radiation, the bomb. In my prints of that period, I was using both white and black dots—stopouts—to activate the surface of the page. That technique gave me a means to irradiate the picture plane. You see it very clearly in the *Fables* of 1955, where the image takes off into this kind of light. I realized the power of what we couldn't see; that is, the molecular nature of matter. Thus, the elements of time, space and matter moved me into galactic space: "The camel's nose under the tent flap."

Your knowledge of space and scientific theory related to space exploration is extensive for a layman. Is this information illustrated in your work? Are you responding in a subjective manner to this information? Or is a combination of both reflected in your work?

I don't think I'm well educated about scientific things. I grasp the issues but I don't have the technical disciplines to get into the equations. I'm not sure I need to. When science offers something new, it alters how artists see. For example, as soon as we knew that blood circulates all through the body, we made figures in the round. Actually, I'm more interested in what is going to happen than in what has happened already . . . or to put it another way, to see the future in the present. When I work, I sometimes feel like an investigative reporter.

Is the color in your prints influenced by actual color discoveries in outer space? Is it based on theory or fact?

I don't know to what degree the photographs of space have been color-enhanced. I put the same color questions to different physicists, and haven't had the same answers twice. Photographs of space return to us as numerically expressed points of light, from black to white. Then color is synthetically assigned to those values. I don't know how close they are to fact, but one would have to be very lucky to get it right.

I believe the clichés of earthly color probably play a big role. NASA has its fish to fry and it likes photographs that the public will enjoy. We see a fair amount of blue in some of those photographs. Yet blue is relatively rare in space. It's an earth color, a function of oxygen. There is very little oxygen in space. Maybe tiny bursts of refracted light may carry blue in them, but big blue fields, such as we see on earth, may not exist in space.

What about color in your work?

In my work, I try to use what color in space might be like. My *Solar Flares*, for example, use intense yellow, white and pale complementaries that intensify yellow and white. We couldn't look at the sun's flares even if we could get close enough. It's a blinding sight. In the final print of the *Solar Flares* suite which I call *Solar Refraction*, I use violet, green, orange, yellow and red, avoiding blue as much as possible. I do not feel obliged to say, "This is how it is." I'm creating metaphors; I'm not illustrating science.

What about black? Black is prevalent in your work.

Yes, I love it. To me, black is the most noble color. Black allows anything to happen, and imaginatively. It doesn't partake of those earthly clichés about what color means: red is blood, blue is sky, green is earth. Such assumptions skew how we look at art.

But, certainly, people have clichéd assumptions about black—void, darkness . . .

Okay, let's say it stands for night. The night focuses my attention. There are fewer visual intrusions. Imagination really travels at night, and I feel free—freer than in the daytime. Black has the total tonal range. By comparison, other colors are very limited in expressive range. You have to do all kinds of things to make them "work." However, when I work with color, I rarely use black, as well.

What about white?

I love white. White is an extraordinarily subtle element. I have done things in which I would mix fifty whites. A white can animate a surface. It's very powerful. One speck of white can enliven a whole field of black. It's like electricity. With much of my work, the drawing is in white, rather than in black. I love it. Black and white together—that's the whole banquet.

Ed Hamilton has been your master printer for over ten years. He's participated with the production of a vast body of your work. How important to your work is your relationship with Ed? Is his influence more than technical?

The way I work with Ed allows me to do what I want to do without negative vibrations at the most tentative stages of an idea. Ed has great curiosity about what's going to happen in a print, and he suspends judgment. He enjoys proofing and he is never negative about long episodes of proofing. If he is unhappy about changes, he doesn't show it.

However, Ed and I both tend to out-subtle ourselves; how close can we come to the edge without falling off? A kind of "Look, Ma, no hands" bicycle riding. We'll pull something that looks great when the ink is still damp, but when it has dried, the bloom has vanished, subtlety shifted from a virtue to a vice. We have to be careful about that.

Ed has a keen color sense, and he loves to pull an edition that is nigh to perfect, every print up to snuff. He is a man of conviction, and he believes that making art is a superior way of life. He also likes the same kind of music I do, so you could say that I'm fortunate to work with him.

Who has influenced your development as an artist?

I would have to say both *who* and *what*. Ideas have always been important to me. Often they're ideas that emerge from fields other than art, because another artist's work is an *answer* and I'm more interested in the question. I had a friend named Harold Jacobson, whom I met in the thirties when I was about sixteen. He was a research chemist, and when Fermi was trying to build a nuclear pile under the Chicago Stadium, he had some very minor part in that project. Harold was intrigued by the oddball that I was, and we had some remarkable conversations, including the interconnection of ideas—like Opus 131, Beet-

hoven and Uranium 235; like Kafka's compressed time and Proust's elongated time. He had the games-playing mentality that you see very clearly in Richard Feynman and in Benoit Mandelbrot. My friendship with Harold lasted until his death.

Another important influence was Jules Langsner, whom I met in the mid-forties. Jules and I carried on a comparable dialogue. He'd come by and the conversation might start with architecture and move into science, or into art, or psychology, or politics, or whatever. I have always had such friends.

What contemporary artist do you admire?

There are so many of them. I admire minimal art. I admire Josef and Anni Albers. Nevelson and I are close and I love her work. Joyce Treiman and I knew each other in Chicago, and I think she is a marvelous artist. There are many who are personal friends.

I'd love to own a Magritte, a Delvaux, an Ensor, or a Rothko. I admire, but rarely love, expressionists; the decibels are too high for me. I do enjoy certain social satire; George Grosz Daumier, Tim. But, by and large, what other artists already have done is not helpful to me.

What about artists from history?

Piero della Francesca. I love the classic calm. Hieronymus Bosch is delicious. I understand and approve of Blake, but I do not love his work. Those endless self-conscious muscles bore me. He was a wonderful printmaker but if you offered me a Blake or a Redon, I would choose the Redon. Who are my favorites today? I preferred Stella before he extruded from the walls. Of that direction, I prefer Elizabeth Murray but I just take artists as they come, on their own terms. I expect the work to be of a certain caliber. Beyond that, I don't rush to judgment, letting my opinion be provisional. Some of the time I am wrong and the artist is right. Other times I am right that the artist is wrong.

You've been painting more and more recently. After a hiatus of some time, how are the new paintings related to the prints?

The paintings are influenced by the prints, and the prints, by the paintings. The material and method I use add a dimension that other materials and methods do not. If an idea is rich, I may do one aspect in a print, another in a painting, and so on. I don't see paintings and prints in a hierarchy, as some people do.

The fact that a painting is unique is a very major difference, is it not?

Not to me, it isn't. I would do lithographs if we could only pull one. In the beginning I used to think of a print edition with the same ambivalence as people must feel who have become parents of septuplets. A print edition means I have to sell the damned things fifteen times, whereas with a painting, once is enough. I did not intend the current boom in population in prints. I think it's decent to keep the editions small and not to paper the world with them.

The paintings are about surface and light. What surface? What light?

In space, there are bodies that give light and others that receive and reflect it. We receive direct light from the sun and reflected light from the moon. Both kinds are ambient light, changing our lives hour by hour. My black paintings absorb the light. The metallic ones reflect it.

How has your position as a feminist influenced your work?

Not a great deal. Feminism has opened up subject matter, and artists are presenting content that was not created before the recent burgeoning of feminism. My *The Dorothy Series* refers to the predicament of women as expressed through Dorothy's

life. Without the women's movement, there would not have been an audience for Dorothy. So, feminism has allowed me a broader choice of subjects, adding to my freedom of thought and creativity.

However, the thrust of my aesthetic is gender neutral. There is very little that feminism or masculinism has to do with my art, but sexism does have a lot to do with whether my art is seen or sold or accepted critically. My interest in galactic space is gender neutral but sexism would have a great deal to do with whether I could be a space engineer. Space is indifferent to gender and infinitely hostile to our species, male and female alike.

Describe the media and processes used in your painting.

I used to paint oil on canvas, but I gave that up in the early sixties because it's an inherently incompatible combination. Oil paint expands and contracts at a different rate than do wood panels or canvas, so that, in time, when temperatures and moisture levels change, oil paintings crack, peel and bloom. Also, oil paintings have to be stored where there is light; otherwise they darken. It's a bad set of materials to use unless you intend to make art that will deteriorate rapidly. I began looking for less viceful materials so that when I made something, it would have a reasonable life expectancy. I began using panels of paper marouflaged to canvas with gesso and gelatin, like *Anki* in this show. Such canvases were very heavy. Recently, I developed a new methodology. *Khis* weighs less than half of *Anki*. I'd rather not explain the new method until I have had the use of it myself as long as possible. "Appropriationists" would use it for all the wrong reasons.

Why is it that there is so little contemporary art that addresses the scientific advances of this century?

I'm not so sure that's true. Albers was a great link between science and art. What about George Rickey? Surely mathematics, engineering and aerodynamics are part of his lexicon. What about Nancy Graves? What about Maholy-Nagy, Kepes, Piene, and the M.I.T. Group, IVAS? Ideas bind contemporary art to the knowledge of our time, much of which is scientific.

Your work is very much an affirmation of the human experience. How is it that you take such a positive position?

I believe my position is more tentative than positive. It's probable that the future will be a disaster. I believe we are going to try to colonize space which would devour our resources with terrifying rapidity. Our planet may have become unreclaimable already, as the ozone crisis and other kinds of pollution are making manifest. I have looked into that wilderness of space and reported back how beautiful it is, but it wouldn't stay that way once we got our nasty little hooks into it. It comforts me that galactic space is not going to welcome us. We are suffocating our world little by little, and it is our friend, our natural habitat: other worlds will do us in a good deal faster. As for living in space cities, you can have a foretaste of that: just spend a week inside any Hyatt Regency Hotel.

Would you like to be the first artist in space?

I'd love to go, but independent thinkers like artists could not exist in the regimented way that space requires. We might poke a brush through the dome. How would you like to spend the rest of your life in the equivalent of a very small shopping mall? I personally believe that the social structure in space would have to be dictatorial. Even if our biological frailties could be handled, is that the kind of life we want?

Through history, artists and their work have been integrated in the culture of their times. But in the last hundred years, artists have become increasingly alienated from the political center of society. Do you think artists have anything significant to contribute to the advance of technological society? And do you think they'll ever have a significant voice again?

As I see it, the only reason to colonize space would be the certain news that the earth is going to collide with another planet. Only a predictable destruction of earth could justify the diversion of resources necessary to colonize in space.

I'm not sure that artists have ever been influential. We have never been the decision makers. We are more like surveyors or archeologists. Our works are the artifacts for future "digs," proof that our civilization passed this way. Just now we make objects that are bought and sold in the art market, but we do well not to confuse the product with its promotion. It's true that by way of designs, our ideas refine such things as furniture and cars and such, upgrading the quality of life somewhat. Some people believe that a work of art is more important than a polyurethane shopping bag; others believe the shopping bag is the work of art.

I want to believe that we improve the quality of life. Some of us are good at what we do, some are only so-so, and some are duds. In this we are like plumbers and presidents. I don't think this artist can afford to give herself airs.

PAINTINGS

ARLENE RAVEN

And how comes gold to be a beautiful thing? And lightning by night and stars, why are these so fair?

—Plotinus

June Wayne has painted the heavens. Space: the time and interval between things; an opportunity for doing something; any immeasurable expanse; stellar depths, magnetic fields, ambient lights; what Wayne calls an "ineffably beautiful but hostile wilderness."[1]

In Wayne's art, astrophysical space is sensate metaphor, created without actual access to the skies. Her firsthand observations from the ground (at the Mount Palomar Observatory) contained neither the grandeur nor the magic of her original vision. Saturn, rather, "looked like a postage stamp on the end of a telescope."

Wayne aspires to immensity. She calls up the sublime. Yet she does not make the big too large. *The Djuna Set* brings together eleven paintings on the subject made between 1984 and 1987. Even the largest of these works are still easel-sized canvases at 4½ feet by 6 feet.

Space stretches by paradox, multiplies through radical abstraction, and magnifies via maximum reflection. *Khis* (1987) fractures the light reflecting off of its silver-leaf surface in increments small enough never to coalesce into interior shapes which would form a composition within the frame. A swift woosh and flutter moves in one direction across the plane; then the wind shifts and blows in another. Atmosphere is the icy after-image emanating from the peaks and crevices, rising into the air shared by its surface and ours.

This atmospheric space is unqualified energy and information, an effluence of pure surface with a life of its own. In rare air, we can become intoxicated. Part of the heady romanticism is a hero we ourselves conjure, the persona of the object-work struggling to encompass conflicts and differences, ambiguities and absolutes, field and detail, idealism and literalness, size and scale, even mythmaking and history.

Wayne experimented with perception in the late forties and early fifties when she created paintings and lithographs in which movement (perceived by peripheral vision) and details (a function of central vision) were brought within the same picture plane, compressing a panoramic vista—what the artist called a "reverse cinerama."[2] *Scanning GT* (1987), her latest exploration in perception, achieves a remarkable synthesis of such fixed and disparate elements as the two identical rectangles of acrylic on wood, the actual hills and valleys of a collaged element of moulded paper—the determined detail in an ever unfurling field, the space-bending but almost imperceptible transition of the surrounding ground from yellow to its polar opposite and magnetized complement, violet.

Wayne recognizes an "uneasy" kinship with Albert Bierstadt, the nineteenth-century landscape painter of the American wilderness. Bierstadt's brushy bravura seems antithetical to Wayne's dense, solid surfaces. Comparing her 1984 canvases to her 1987 efforts, we can see that she has pressed together what may have been a more porous surface, and has eschewed any eccentric detail. Nothing so idiosyncratic as a signature brushstroke can be seen in any of her *Djuna Set* works.

1. All quotations by June Wayne are from an unpublished manuscript, 1987.
2. See Mary W. Baskett, *The Art of June Wayne* (New York: Harry N. Abrams, 1968).

But still she is moved by the hedonistic and moralizing sentiment of Bierstadt's majestic landscapes, and if she has purged these elements from, at least, the appearance of her paintings—works which can also be called landscapes, although of galactic ground—perhaps their scope and standards concur across the centuries. Like Bierstadt, Wayne's primary encounter as an artist is with nature.

But let us consider Wayne's nature as well as the nature of her interest in the physical world. Her 1984 paintings in primary and near-primary hues—blue (*Hel*), red (*Rhed*), yellow-gold (*Jev*)—analogize physical states and substances as totalities. She has created "fields" (as did Mark Rothko and Barnett Newman) which are wholly literal (as were Frank Stella's early black stripes). *Hel* is a territory dominated by oxygen; *Redh*, the red earth of the red planet; *Jev* is rich in mineral mines, the paths of its arteries paved in gold.

Wayne made aircraft blueprints into three dimensional drawings based on classical perspective during World War II. She reflected on the rules of perspective as generalizations which are law only within certain angles of vision and which can break down, revealing an opportunity for invention.[3] She generated this arena for her own inventions in the *Djuna Set* paintings through light, time, inference, and surface.

Wayne takes Leonardo da Vinci as a model of modernism. Da Vinci, whose drawings from nature track an "invisible *energy* that was shaping the trees and carving the waters into waves," created an open-ended conceptual art fueled by scientific curiosity. Working in the 1980s, Wayne has recaptured the conceptual tensions firing the origins of twentieth-century modernist art which, if severed from trans-physical forms (as they have been in the past several years), can only express the rank materialism that modernist art once sought to transcend.

In a fundamental way, Wayne seeks to explore, not eclipse. Though narcissism abounds, larger-than-life dreams are suspect in the culture of the 1980s. Wayne herself has always been impatient with overblown paeans to the hierarchical higher realms. She does not see herself as a savior who will purify, ennoble, or change life itself in any way. Hers is not a sentimental vision of history, epistemology or social relations tied either to art-historical conventions or religious traditions. She was fascinated by the exchange of energy and matter in Leonardo's work. She has expressed the same exchange in her simultaneously ethereal and concrete forms—as incarnate and in-themselves rather than as once-removed illustrations of imagined metaphysical regions. Refusing to take up the old dualism between the material and immaterial, this artist has, instead, sought to traverse a greater and more profoundly vast physical reality.

"We see the light that left a star eons ago, a star that probably no longer exists except in that traveling light." Light marks place and time and is Wayne's most visible energy. A beam splintered in a prism can yield her red, golden yellow, silver-white and blue surfaces. Sunshine and firelight are temperature, or a level of saturation of color—leafed in precious metals or applied twenty times or more in thin washes of paint. *Zuhl, Flor,* and *Anki* (all 1984) are aspects of the same post-Impressionist universe of lights, but breaking closer or farther away, at midday or twilight, across mountains or deserts; as constellations, ocean mirrors, or galactic geyser sprays. Wayne's super-chromatic hues have an absolute potential to be the very hottest and coolest at their most intensive degrees of illumination.

Wayne's is an emphatically conceptual art (imagining what she has not seen), and—just as emphatically—an entirely visual art. Pure in their forms, at the same time her surfaces owe to photography and technology for the sources of those forms. *Djuna* (fig. 1), the painting which names the series gathered here, can be seen as a pivot for further reflection on the cosmic polarities of Wayne's art.

Djuna is a gritty fusion of coal and ebony, yet still gleams—a lusty mineral glint—as one passes by. If silver and gold predominate elsewhere, *Djuna* may mark the trajectory between these shining reflectors and their base metals. A magnifying telescope can start a fire with sunlight. Is *Djuna* a burnt offering testifying to the existence and power of that dazzling, carcinogenic light? Apollinaire saw painting as fire, possessing the fact and truth of its own light. Wayne has painted fire and, as well, coal (the fire-starter), soot, carbon and smoke.

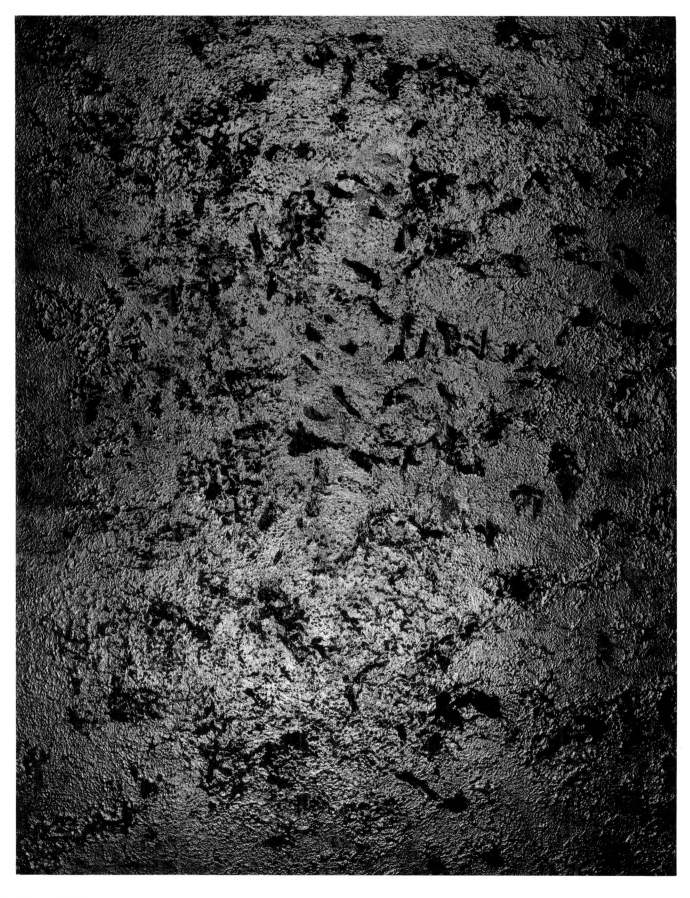

1. *Djuna*, 1984
 Acrylic on canvas
 54 x 72 in.
 135 x 180 cm.

TAPESTRIES

BERNARD KESTER

In a pursuit to intensify the veracity of her visual language, June Wayne expanded the range of her expression in 1971, moving beyond printmaking and painting into the tapestry medium. Configured by the same precise vision that has informed her paintings and lithographs, Wayne's tapestries speak in a grand scale that also reveals the resiliency of the wool thread employed in a method that is both rhythmical and sequential—weaving. She chose tapestry also because it carries a long tradition of monumental size that is not usually obtainable in other art media, and because the element of time contained within the weaving process itself is cumulative, and remains implied in the result.

Having probed the limits of natural terrestrial and atmospheric phenomena as resource for her art, Wayne has more recently extended her investigation into the ultimate wilderness of astrophysical space. Seeking all relevant sources of observation and fact, she has studied scientific literature and information, she has initiated dialogue with physicists, and has personally inspected the galaxy through the most powerful telescope in the West in order to examine her subject in an intellectual and formal sense, free of associations that derive from age-old romantic, religious, or mythological beliefs. Neither Cassiopeia nor Orion has a place in this firmament. However, NASA's extraordinary recording of the cosmos through electronic scanning converted into photographic enlargements has provided an important and fertile reference for Wayne's inquiring mind and imagination. Associating the scanning monitor as it reveals images in an additive way, point by point, with the incremental vertical/lateral interlacement of threads during weaving makes clear an aesthetic connection between process and form. The fundamental grid system that underlines both media remains an impersonal and orderly means of reportage on the one hand, while on the other, it allows images to be disclosed, modified, and humanized by the intervening hand and pulse of the weaver.

In fact, Wayne's first tapestry, *At Last a Thousand* (1971), pre-dates many of the great photographs of space, yet it predicts the imagery of her newest works. Intense in its black/white composition, this tapestry speaks with power and dramatic impact while it remains essentially graphic in nature. It generates its force and movement through its great scale and by its *pace*. Land mass is surrounded and consumed in calamity by an enveloping cloud and its pervasive condensation. It moves and swells, it unfolds slowly, and gradually engulfs. The viewing *pace* emanates from the measured sequence of intersecting threads intrinsic to the weaving process.

In *Lemmings Day* (1973), Wayne manipulates black with white almost equally to evoke the threatening flood-drenched, windswept primordial terrain that reaches beyond the tapestry borders. Within the catastrophic movement emphatically expressed, numbers of generalized figure forms are compelled to tumble headlong across a harsh and mottled plane toward the abyss, providing a stark narrative component that is told with accelerating speed.

A projectile has reached its mark, the helix spins into the vortex, and *Target* (1972) reverberates into transparent eliptical quadrants of overlapping organic and geometric patterns that are visual aftershocks. The sensation is prolonged while the viewer scans these patterns revolving in their orb.

Color enters *Onde en Folie* (1972) in a declarative, albeit additive way, since the composition is fundamentally defined in black and white. Strident red magnifies the reach and power of the giant fingers of a violent wave. This is a close-up slice of time awash in a rampage.

Wayne's *Verdict* (1971) (fig. 2) contains certain characteristics associated with the classical tapestry tradition that are not apparent in other works shown in this selection. Here is a splendid fullness and resonance of color. Bits and points of intense hue mingle among neutrals, building color atmospherically and perceptually that move the viewer across the tapestry, encouraging inspection of its surface details as well as its primary image. Developing a full sense of totality and cohesion, *Verdict* attains the quality of grandeur. Bordered at the top and configured vertically, this work recalls the dense, stacked compositions typical of early Gothic tapestries. Acknowledging the limitation of the two-dimensional plane, there is no intention to pictorialize spatial depth. The woven surface becomes an eroding relief, a close-up view of a rock facade, a giant chiseled mountain-scape defined by an irregular pattern of shadows at a moment of intense light. Certain literary associations, cryptographic and organic elements become visible in a deliberate reading: Symbolic clusters of stars, the genetic code, the double cross, and planetary erosion in a span of time.

When Wayne decided to extend her work into tapestry, she contacted her friend, the late Madeleine Jarry, former Inspectrice Principale de Gobelins in Paris, who introduced her to certain ateliers in France experienced in adapting large designs to their looms, ateliers that could transform Wayne's cartoons under her supervision into tapestries employing the classical interlocked tapestry weave. At that time (1971) there was no comparable workshop in the United States where artists could have designs translated in cooperation with professional handweavers.

In fact, Wayne's first tapestries appeared in the midst of the international fiber movement that began in the 1960s which favored the conscious exploration of materials for their structural and tactile properties developed into experimental and expressive forms that were most often large, textural, and robust. Emphasis was placed on material presence rather than image development. However, by the late 1970s, a renewed discipline of control in favor of surface and image began to reappear in fiber work. Idea and material became compatible again as materials and processes grew less assertive. Unaffected by such stylistic developments and movements, Wayne's graphic sensibility and respect for the woven surface have predicted this restraint that has returned to work in fiber.

Wayne's interest in tapestry did not develop from a need to revive or perpetuate classical procedures, nor did it derive from an exploratory involvement with textural materials or weaving techniques. She came to tapestry as the most suitable means for her visual metaphors while employing sensual materials to invoke an intellectual sensibility. The weaving of tapestry is intensive, rhythmical, and slow. In these characteristics, Wayne found a direct and appropriate way by which she could transmit to the viewer a sense of *time passing* that is internal to the process. She can lead the viewer beyond *real time* to read certain works at a quickened *pace*, or to perceive others in extended *cosmic time*.

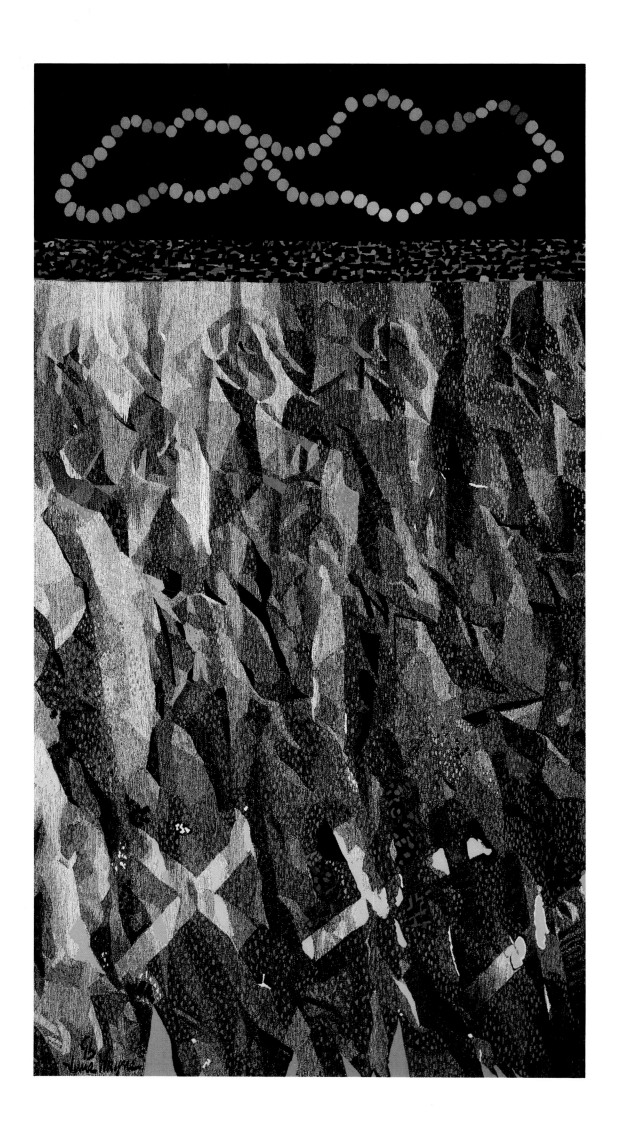

2. *Verdict*, 1971
 Tapestry
 10 x 6½ ft.
 3.05 x 1.98 m.

LITHOGRAPHS

PAT GILMOUR

O chestnut tree, great-rooted blossomer,
Are you the leaf, the blossom, or the bole?
O body swayed to music, O brightening glance,
How can we know the dancer from the dance?
 —W. B. Yeats

"Truthfully," June Wayne told an audience in 1984 at an exhibition celebrating the 25th anniversary of the famous workshop she founded, "I am weary of Tamarind."[1] And both then and since, it has been possible to detect a note of regret that although she quit Tamarind eighteen years ago, she will be forever associated with the institution through which she so brilliantly changed the ecology for lithography in the United States, rather than with her own art-making.

Even as she was formulating the lucid plan which brought the Tamarind progam into being, June Wayne assured W. McNeil Lowry of the Ford Foundation, whence came the necessary funds, that he need not worry if the project fell through as "the artist in me will be vastly relieved not to sacrifice my worktime."[2] And although she has since referred to Tamarind as a work of conceptual art, in fact, during the decade in which she was the workshop's director, she largely suppressed her personal output and went without a dealer, rather than risk any suggestion of conflict. The more visibility she achieved as Tamarind's director, the more obscure she felt she became as an artist. Nevertheless, an *Art Journal* writer shrewdly recognized that June Wayne's design for the Tamarind movement revealed "the same aesthetic and philosophic scope" as her image-making.[3] Indeed, this could be said of any of the myriad activities in which she has engaged, whether rallying forces against some of the more stupid decisions of bureaucracy, eloquently clarifying the burning issues of the day on radio or television, or writing witty papers like "The Male Artist as Stereotypical Female," in which she urged her fellow artists to place more faith in their intellects and counteract the "demonic myth" representing them as inchoate, emotional romantics.[4] Not that her devastating logic and intellectual toughness (so unnerving to adversaries, so reassuring to those she champions) have ever outweighed her capacity for passion and feeling.

1. June Wayne, extemporaneous speech, Grunwald Center for Graphic Arts, University of California at Los Angeles, 2 December 1984.
2. June Wayne, letter to W. McNeil Lowry, 17 July 1959.
3. Editorial introduction to June Wayne, "The Male Artist as Stereotypical Female," *Art Journal*, 32 (Summer 1973), pp. 414-16.
4. June Wayne, "The Male Artist as Stereotypical Female," p. 414.

In a recent paper about her aspirations, June Wayne acknowledged that the circumstances requiring her to earn a living "to support the habit of being an artist" had also furnished many aesthetic ideas, from optical conundrums to symbolic narratives.[5] In addition, the valuable audiovisual skills she learned while earning her daily bread had subsequently proved useful for various media hybrids, just as liaising with technical specialists had contributed to her ability to master tapestry and printmaking. Writing for radio in Chicago, accessory designing for the garment industry in New York, and helping workers visualize the airplanes they were building for the war effort in Los Angeles, all provided grist to her aesthetic mill. Then, while Tamarind temporarily deflected her from the full-time realization of her own work, it involved her in the reinvention of lithographic collaboration in an American setting. This secured the future in America of a technique she had loved from the late 1940s and by providing training for a generation of master printers, helped make possible the aesthetic subtleties in lithography so appropriate for the work she does today. It can therefore be said of her—as has often been said of John Donne, one of her heroes[6]—that the artistry with which she orders her experience draws on the whole person—the senses as well as the reason, passion as well as intelligence.

For twenty years now, June Wayne has made paintings, lithographs and tapestries inspired by "the ineffably beautiful but hostile wilderness of astrophysical space," a wilderness which fascinated her "where past, present and future coexist in fugue-like overlays." Ideally placed for such a quest in California, she has been stimulated by visits to the observatory at Mount Palomar, by regularly reading the scientific literature, by discussing the latest discoveries with physicists or astronauts, and by reviewing the pixels that stream to earth from unmanned space probes. In addressing herself imaginatively to our post-Sputnik universe, she has considered the nature of energy from protoplasm to galaxy, and with it the inevitable philosophic questions concerning origin and destiny. The work that has resulted has not been motivated by a desire to illustrate new physical theories, but to invent metaphors which expand aesthetic sensibilities. In this respect art, like science, widens our knowledge by representing possibilities and making inferential constructions, so that any new image or metaphor offers analogies that no one noticed before. A motif is captured in terms of a medium, having been relayed through a frame of reference constructed in the mind from the available facts and theories.

To contemplate outer space is to explore an unearthly realm, most of which is—and will remain—far beyond the reach of immediate experience. It is a world ranging from thermonuclear heat to absolute zero where unimaginable distances, whether minute or immense, are measured in units from angstroms to parsecs. Some billions of years into the future, our sun will ignite and become a "red giant," swallowing the earth as it expands; oceans will boil, continents melt, and the earth will vaporize. In the meantime, like all other stars, the sun emits protons and electrons in the form of solar winds, which spew from its upper atmosphere at high speed and, at times, blow with great fury. The outer envelopes surrounding dying stars appear to us as beautiful planetary nebulae and furnish the elements from which the world and we ourselves are made. Quite literally, from star dust we come, and to star dust will return—as June Wayne's self-portrait, superimposed on a stream of energy-made matter, implies.

The artist has always pursued a vision remarkably unaffected by fashion, or the prevailing styles. For despite the interest in the fourth dimension displayed by some twentieth-century artists, the modernist preoccupation with flatness has in many ways discouraged the visual exploration of space-time, as did postwar American art, with its insistence on two-dimensional materiality. It is hardly surprising, therefore, that June Wayne has looked for inspiration not to her contemporaries, but to artists of other centuries who handled related problems. She greatly admires Leonardo's drawings of the deluge which, blending logic with expressive purpose, made energy visible in pictures of cataclysmic turmoil by drawing atmospheric currents like cascades of water. Turner translated sublime atmospheric effect into images of "tinted steam" described by Hazlitt as "pictures of nothing and very like" and conveyed (often very pessimistically) the velocity of destructive energies unleashed by the impersonal power of nature. Perhaps most surprising among her acknowledged influences is Albert Bierstadt, who regarded the overland trail to California, much as we regard outer space today, as the ultimate frontier.

5. June Wayne, statement of plans, 1987.
6. June Wayne was one of the first American artists to illustrate a great poet; she completed her lithographs for John Donne's *Songs and Sonets* in December 1958.

Bierstadt's canvases celebrated the grandeur of unexplored mountain peaks, making them appear immanent by dematerializing them with an effulgence of light. His paintings helped convince his contemporaries of the need to preserve the wilderness as an unspoiled Eden. "His coloristic bravura and even his sentimentality," says June Wayne, "touch me in spite of myself."

The artist's regeneration of lithography moved into high gear in Europe in the 1950s when she was searching for ways to complement Donne's poetry. Whereas lithography in the United States had all but disappeared, in Europe it was "as if all composers were orchestrated in the same key for four or five instruments." When she first started drawing lithographs in Los Angeles, she was fascinated if her materials reacted unexpectedly, regarding this "as a demonstration of the stone's life."[7] Experimenting later with zinc plates in Paris, she sprayed and puddled liquid tusche, allowing it to oxidize and delighting in the resultant tissue of fissures like skin, or granular clusters like nebulae, that the chemical combination of zinc and oxygen suggested. While Donne's world view was bound by the Empyrean heaven as an abode of God, June Wayne's technical strategies were equally adaptable to the intimations of twentieth-century science. As early as 1926, Kandinsky, considering the point in art, juxtaposed a photograph of the Hercules star cluster with another of nitrate-forming modules enlarged a thousand times, observing that the world was a self-contained cosmic composition which could be systematically analyzed into endless independent compositions until one arrived at primordial form.[8] June Wayne's contribution lay in conspiring with the lithographic process itself to generate images by harnessing natural phenomena. In magnificent compositions like *Silent Wind*, where the structures spawned by the zinc are handled with masterly discretion, the chemical action becomes a paradigm for the invisible energy of stellar winds converted into matter in space—suggesting the attendant shock waves or magnetic forces of emissions streaming from the stars.

Another device she has made very much her own is the "rainbow roll"—a way of simultaneously imposing several lithographic colors from one passage of the inking roller. This technique has been used since the early nineteenth century, primarily as a parsimonious tactic for achieving several colors for the price of one. Revived at Tamarind, "it passed like Asian 'flu from artist to artist," although June Wayne originally adopted it as appropriate to her image system, sensing its ability to address issues like those in Turner's "color beginnings" or in Leonardo's handling of *sfumato*. The imperceptibly graded veils of lithographic ink thus became an ideal procedure with which to convey the relativity of space and its ambient lights. While any fool can print a crude merge, betraying its creaking mechanism by ugly striations, Edward Hamilton, the artist's personal printer, has honed the skill with exquisite finesse. Displaying a sophistication only to be acquired by one who daily practices his craft, Hamilton can graduate blends with the most gentle gradients, accumulate spots of color with edges as soft as smoke, develop periodic emphases to suggest pulsating rhythms, or seamlessly merge the radiant spectral colors that are refracted by prisms to open stained glass windows into the heart of an atom, or the constituent elements of a star. Artist and printer combine their knowledge and skill to devise extraordinary effects, most of which defy description. Consider the complexities of *Green Edge*: a broad outer border descends effortlessly from sage green to a warm dun, suggesting the merest tinge of greyish-mauve en route. Pierced on one side by a shaft like the leaf of an iris, the outer field is also irradiated by two electrifying flares, which suggest the wild and spontaneous movement of escape. One, brilliant red, is echoed by an angular current, another mutates mysteriously from eau-de-nil to palest leek, its flotsam jettisoned into another dimension. The flares appear to leap from both sides of a vermillion-to-orange pixel of indeterminate scale, glowing as it traverses an inner rectangle. This central area, in its turn, is orchestrated from strong lilac through tan to nut brown, while its outer perimeter is edged in a slightly astringent, new-leaf green, which incontinently scatters a powdering of its color, like dust, from one of its corners. This extraordinary composition celebrates the unexpected—the spatial ambiguities of the free-floating forms, the conjunctions of subtle and surprising greens and the two conventional frameworks unable to restrain the internal eruptions—so that one might fancifully interpret the image as scientific perplexity in the face of the intractable universe. Although a superb variant of the print promises greater

7. Mary W. Baskett, *The Art of June Wayne* (New York: Harry N. Abrams, 1969), p. 53.
8. W. Kandinsky, *Punkt und Linie zu Flache (Point to Line and Plane)* (N.p.: Bauhaus Book, 1926).

stability by replacing the eerie outer field with the unvarying constancy of black, in fact the impenetrable darkness renders the drama of the escaping flares more frighteningly ungovernable.

One of June Wayne's most remarkable achievements is the variety of invention that she has been able to distill from the lithographic process coupled with her imaging of such intangible concepts as luminescent gas, expanding radiation or interplanetary dust. Her abstract visual poetry can encompass the strange bruised weightlessness of *Vio*, a shower of pearl-white meteorites raining through the dense grey magnetic field of *Lodestar*, or *Solar Flares*, a suite which looks without terror into the unbearable heat of the sun and frets a delicate lacework from the fiery yellow corona of the solar disc. The most recent prints, some of which include collaged elements, relate to her *Cognito series* of paintings, like slabs of planetary surfaces clothed in silver and dematerialized by light. Sober, yet rich, these works on paper—presenting simple forms like doorways or floating laminae—contrast borders of dove-grey cloud with hearts of mottled pewter, or textures shining like blue-black coal with passages of milky translucency or molten silver. Such comparative austerity is a far cry from the *plein-air* gorgeousness of *Between I and II*, in which lilac-pink, yellow-green and marigold strata, elegantly punctuated by wisps of mackerel cloud, suffuse the Californian sky intensifying at sunset, watched from the balcony of a condominium.

In 1976, June Wayne ended an article she was writing by asking what it meant "that our molecules are no different than those in a doorknob."[9] Rather than viewing this fact as confirmation of the oneness of things, it seemed, for her, to deny the uniqueness of the individual. But whatever strange, charmed or colored quarks she shares with her doorknob, there is no doubt about the individuality of the particular patterns of energy that constitute June Wayne—a person whose head may be among the stars, but whose feet are firmly on the ground.

When she was honored (again!) in 1985, Ruth Weisberg, surveying the rich diversity of her career, singled out for special comment her visionary imagination, her disciplined restraint, and her maturity of approach combined with youthfulness of ideas.[10] Weisberg also used words like tough, eloquent, passionate, audacious, witty and intelligent to describe qualities that all admirers of this dynamic woman will instantly recognize—qualities as evident in her art as in her life.

9. June Wayne, "The Creative Process: Artists, Carpenters and the Flat Earth Society," *Craft Horizons*, October 1976, pp. 30-31, 64, 67. (p. 67).

10. Ruth Weisberg, presenting June Wayne for an honor award, National Women's Caucus for Art Conference, Los Angeles, 12-16 February 1985. Since 1950, June Wayne has been honored more than 35 times, including a CINE Golden Eagle and an Oscar nomination for the film *Four Stones for Kanemitsu*, a documentary film on lithography made in 1974.

PLATES

1. *Setsun*, 1983
 Lithograph
 My Palomar Series
 18½ x 16 in.
 47 x 40½ cm.
 Artist Proof B

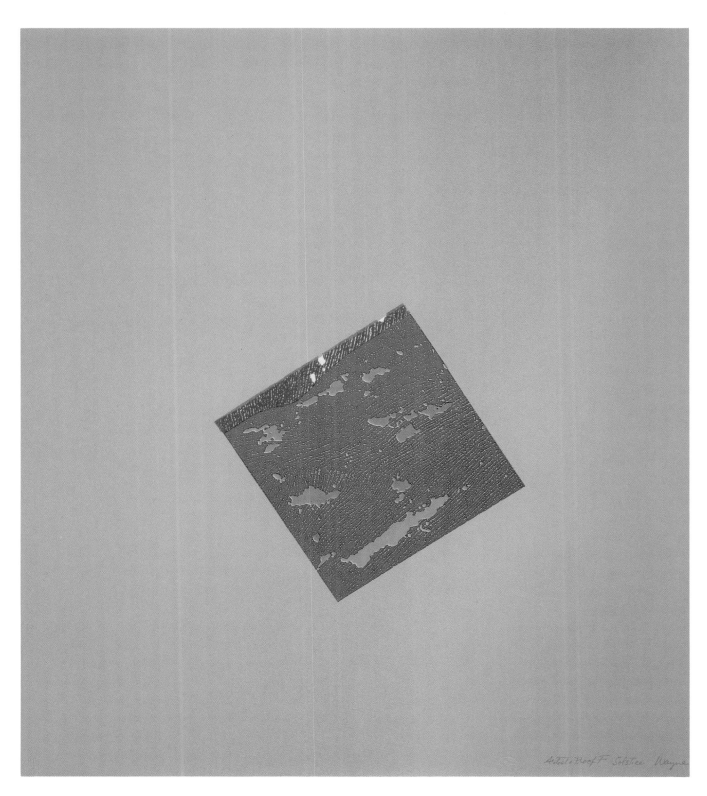

2. *Solstice*, 1984
 Lithograph
 My Palomar Series
 18½ x 16 in.
 47 x 40½ cm.
 Artist Proof G

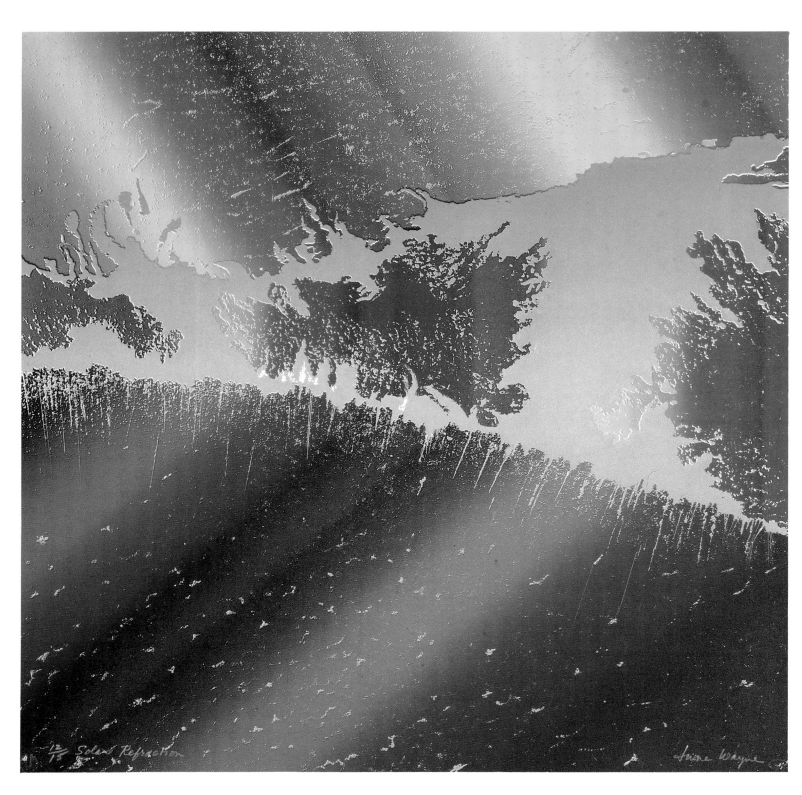

3. *Solar Refraction*, 1982
Lithograph
Solar Flares Suite
17¼ x 17 in.
44 x 43 cm.
Color Trial Proof 3

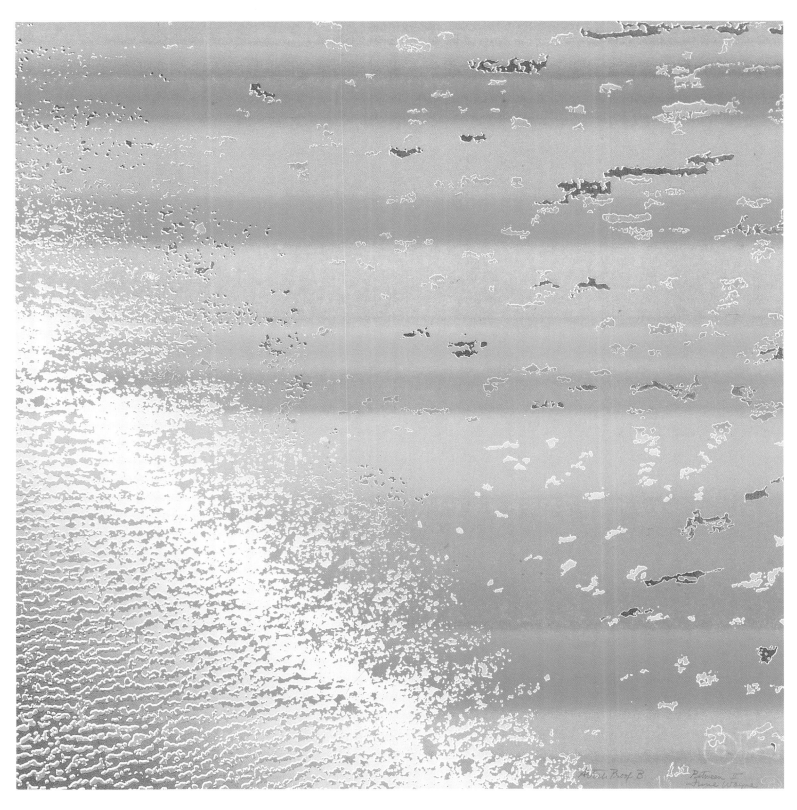

4. *Between II*, 1983
 Lithograph
 18½ x 21½ in.
 47 x 54½ cm.
 Artist Proof A

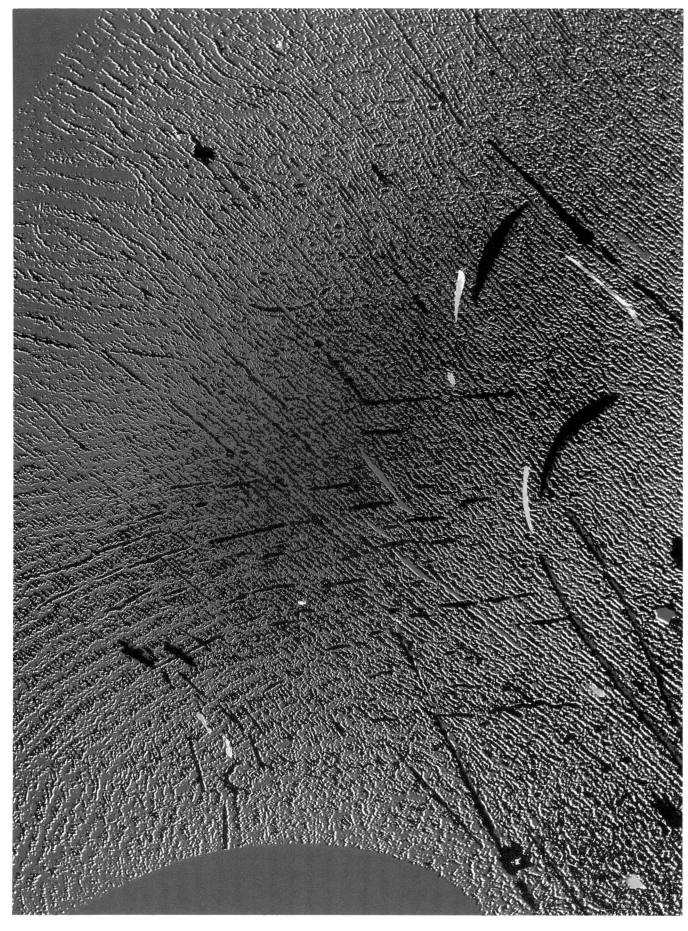

5. *Glitterwind*, 1981
 Lithograph
 12⅞ x 9⅜ in.
 32¾ x 24 cm.
 Edition 10/10

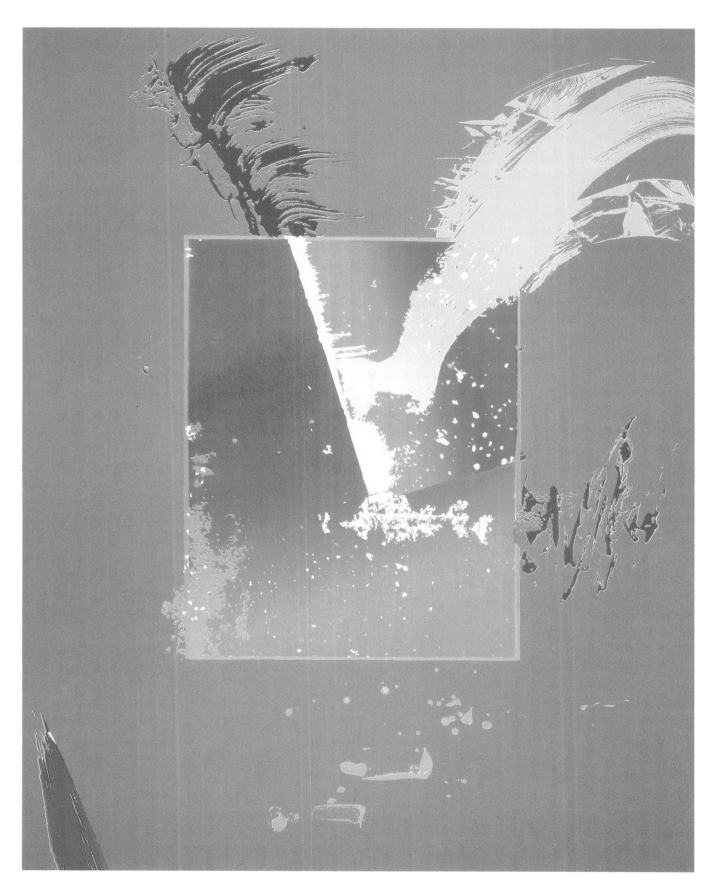

6. *Green Edge I*, 1986
 Lithograph
 24¾ x 19 in.
 62½ x 48 cm.
 Exhibition Proof

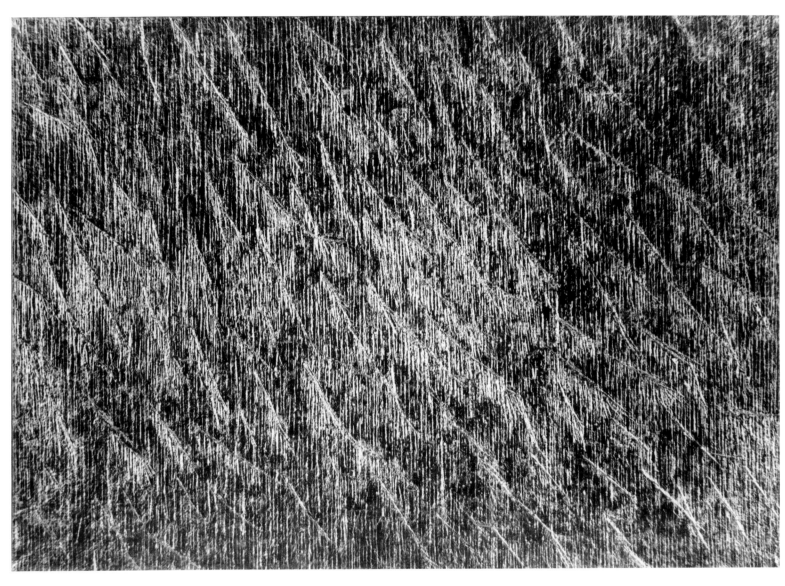

7. *Ari*, 1984
Acrylic / silver
leaf on canvas
54 x 72 in.
135 x 180 cm.

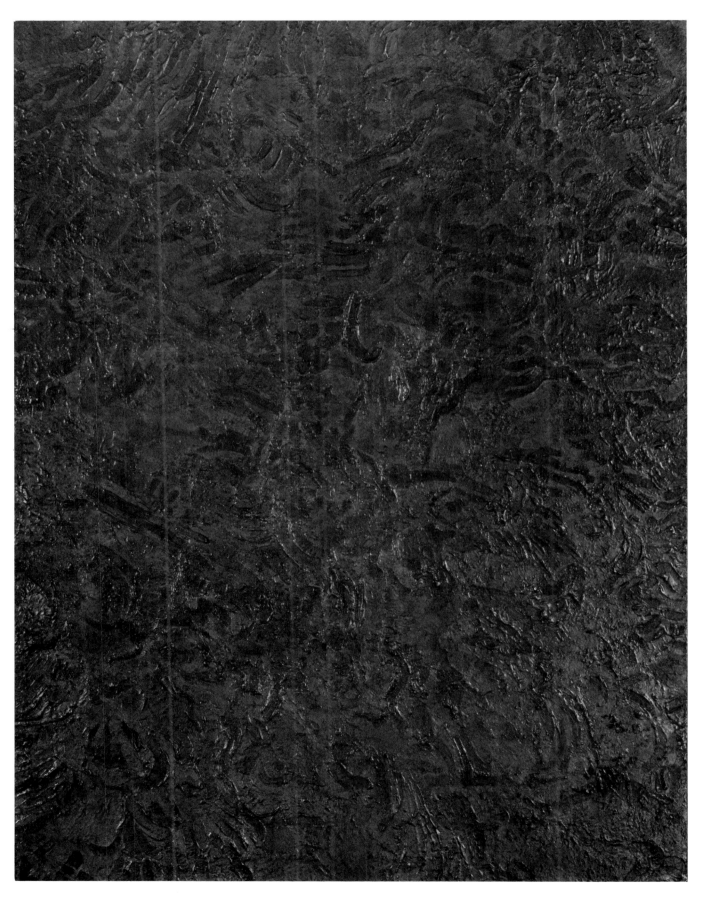

8. *Rhed*, 1984
 Acrylic on canvas
 72 x 54 in.
 180 x 135 cm.

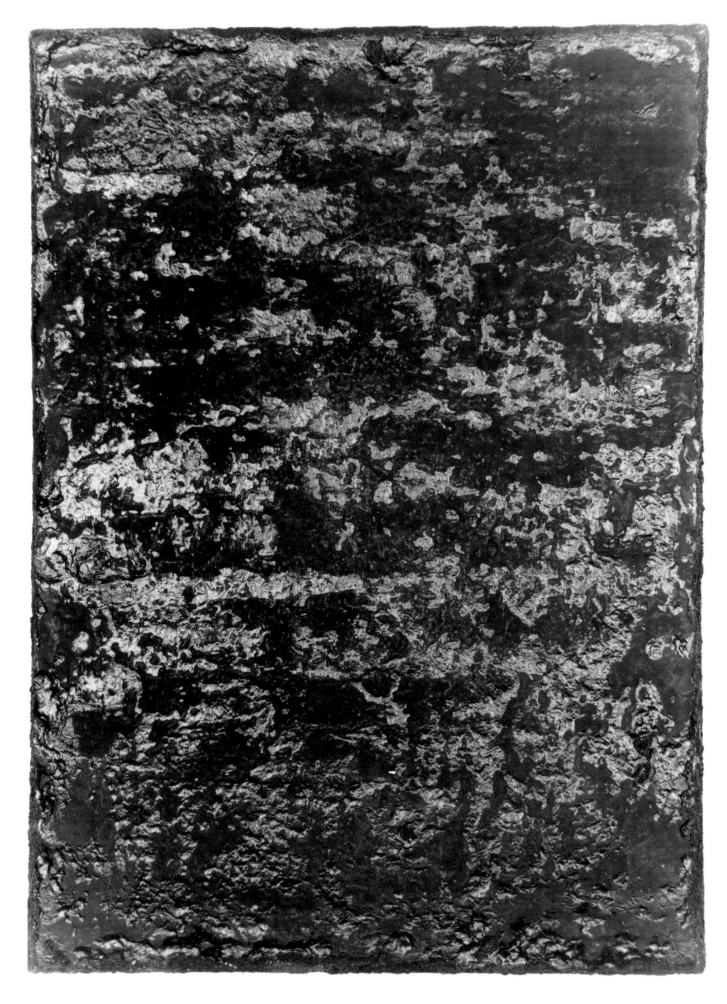

9. *Zhule*, 1984
Acrylic on panel
on canvas and
gessoed paper
40 x 30 in.
90 x 75 cm.

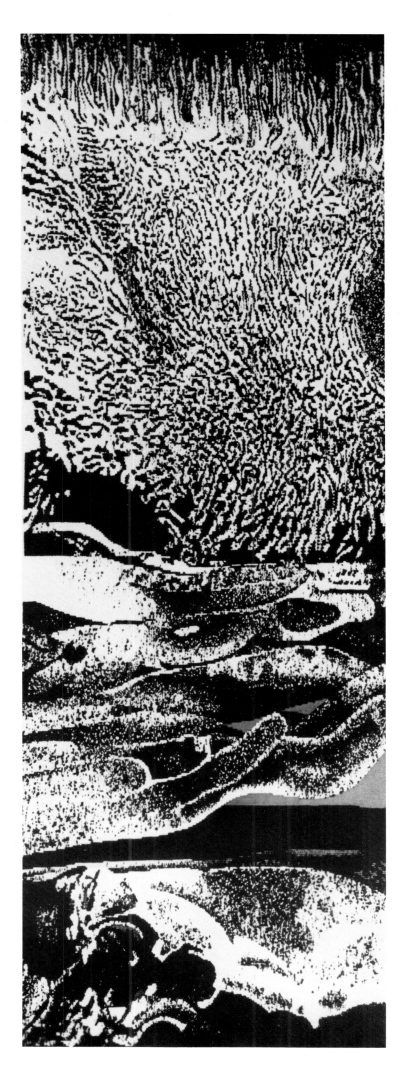

10. *Onde en Folie*, c. 1972
 Tapestry
 10 x 3 ft.
 3.05 x 0.91 m.

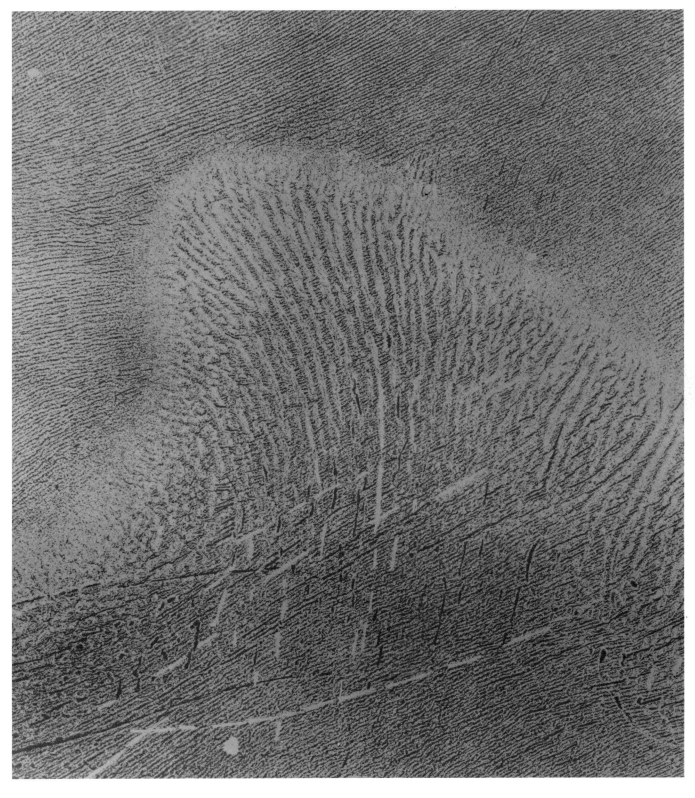

11. *Astral Wave/White*, 1978
Lithograph
Stellar Winds Suite
11⅛ x 9½ in.
28 x 24 cm.
Artist Proof F

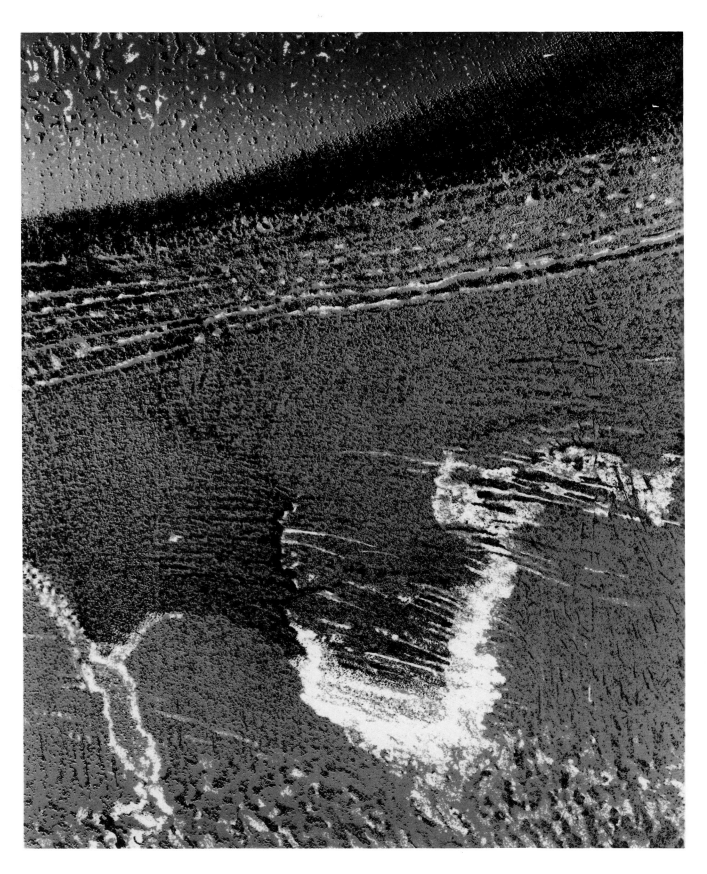

12. *Debristream*, 1979
 Lithograph
 Stellar Winds Suite
 11 x 9⅜ in.
 28 x 23½ cm.
 Artist Proof D

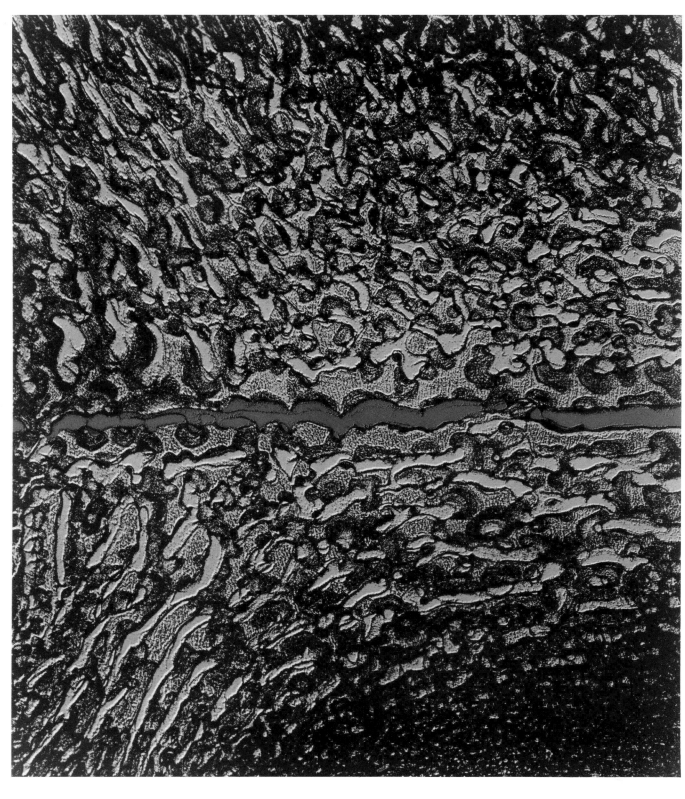

13. *Double Current*, 1978
Lithograph
Stellar Winds Suite
11 x 9⅜ in.
28 x 23½ cm.
Artist Proof D

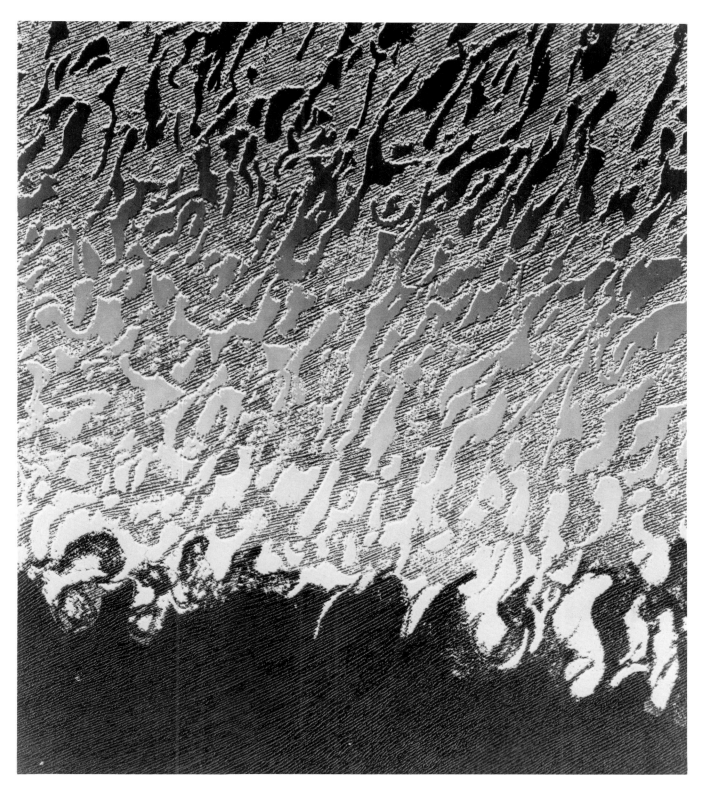

14. *Frothing*, 1979
Lithograph
Stellar Winds Suite
11 x 9⅜ in.
28 x 23½ cm.
Artist Proof F

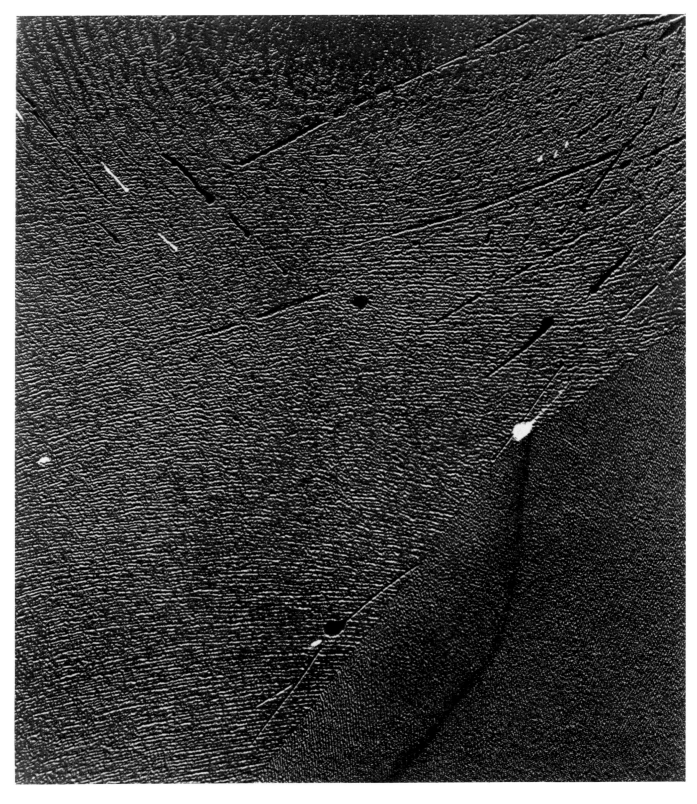

15. *Scintillae*, 1978
Lithograph
Stellar Winds Suite
11 x 9¼ in.
28 x 23½ cm.
Artist Proof H

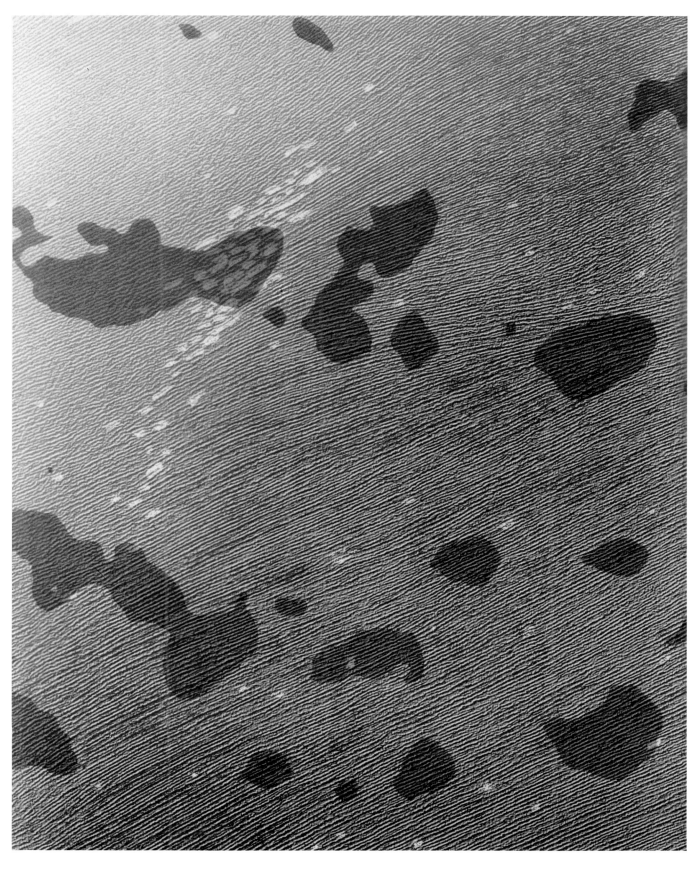

16. *Star Shower*, 1979
Lithograph
Stellar Winds Suite
11 x 9⅜ in.
28 x 23½ cm.
Artist Proof C

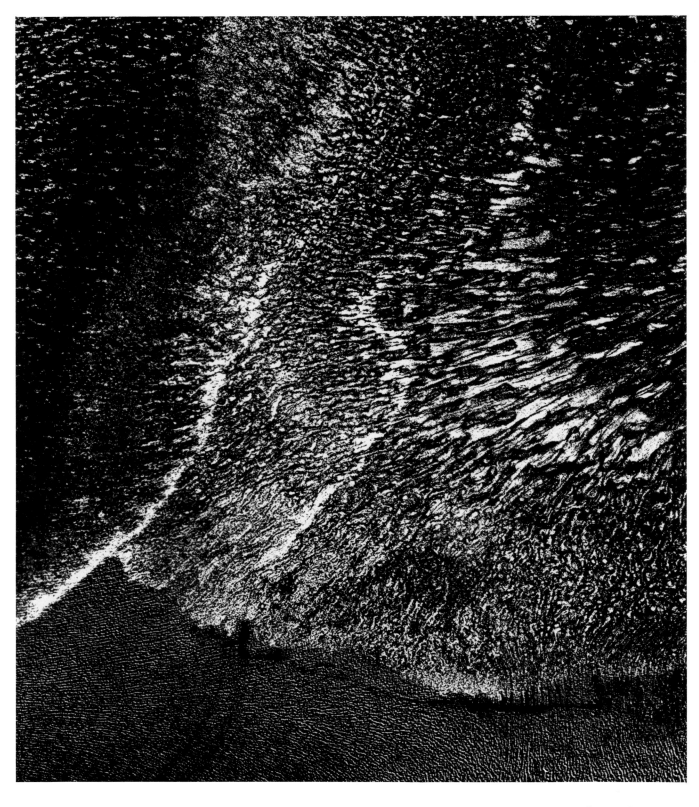

17. *Stellar Roil*, 1978
Lithograph
Stellar Winds Suite
11 x 9¼ in.
28 x 23½ cm.
Artist Proof E

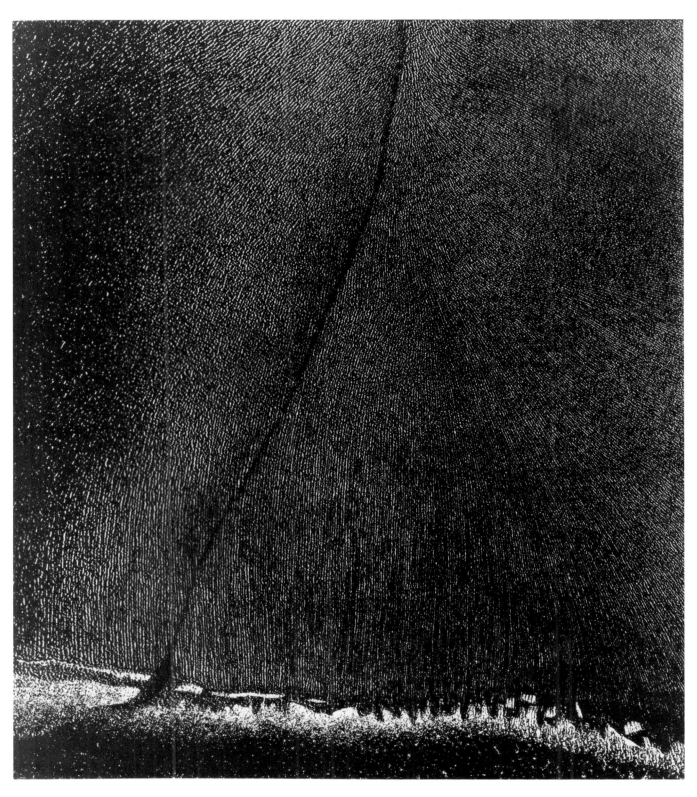

18. *Wind Veil*, 1978
Lithograph
Stellar Winds Suite
11 x 9¼ in.
28 x 23½ cm.
Artist Proof F

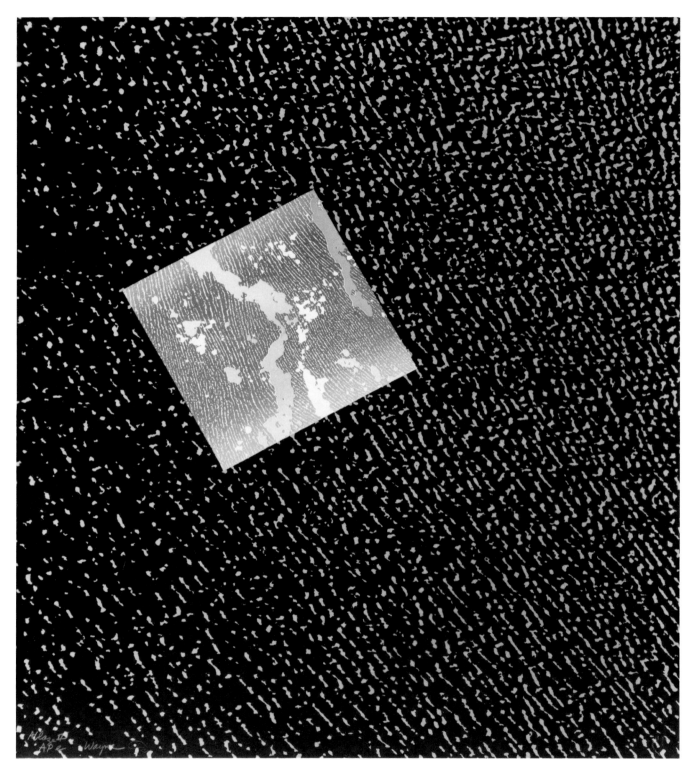

19. *Ablaze II*, 1984
Lithograph
My Palomar Series
18½ x 16 in.
47 x 40½ cm.
Artist Proof B

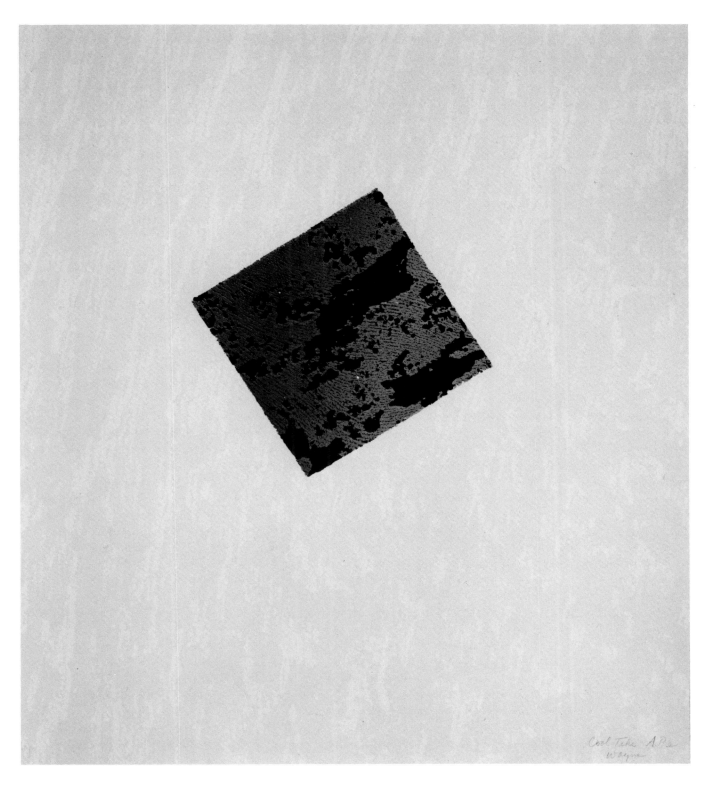

20. *Cool Take*, 1984
Lithograph
My Palomar Series
18½ x 16 in.
47 x 40½ cm.
Artist Proof B

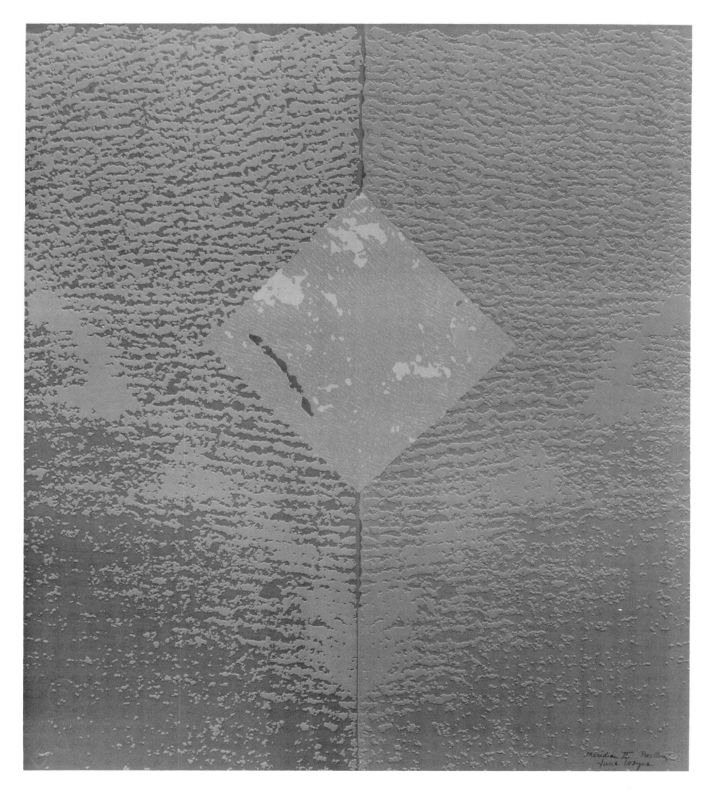

21. *Meridian II*, 1985
Lithograph
My Palomar Series
18½ x 16 in.
47 x 40½ cm.
Artist Proof A

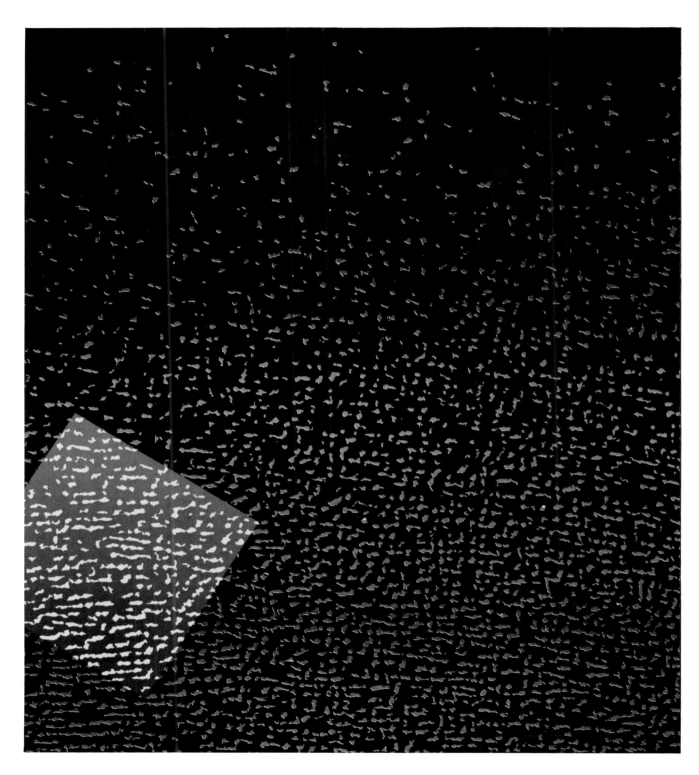

22. *Night Field*, 1984
 Lithograph
 My Palomar Series
 18½ x 16 in.
 47 x 40½ cm.
 Artist Proof B

23. *Over and Out*, 1984
Lithograph
My Palomar Series
18½ x 16 in.
47 x 40½ cm.
Artist Proof B

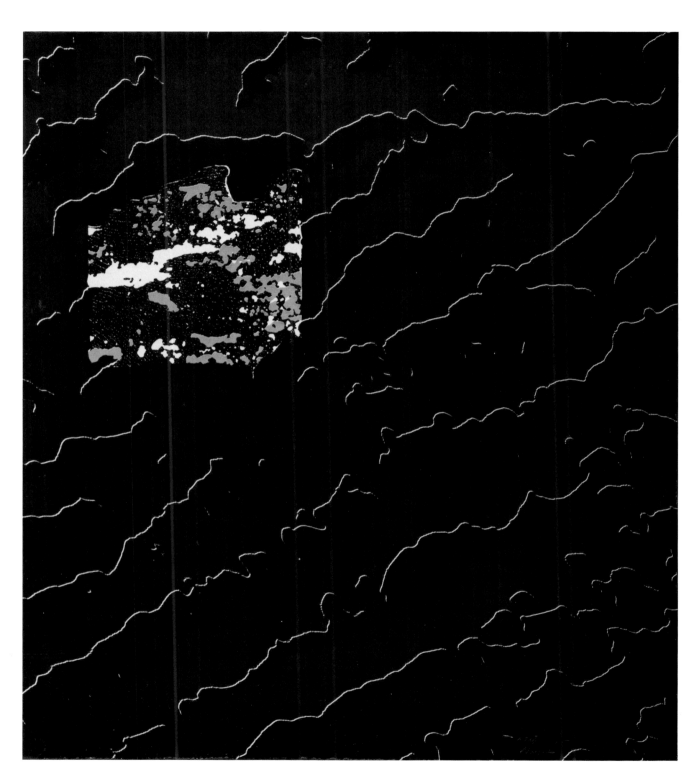

24. *Twinight*, 1983
 Lithograph
 My Palomar Series
 18½ x 16 in.
 47 x 40½ cm.
 Artist Proof C

25. *Solar Flame*, 1981
Lithograph
Solar Flares Suite
16 x 16 in.
40½ x 40½ cm.
Artist Proof B

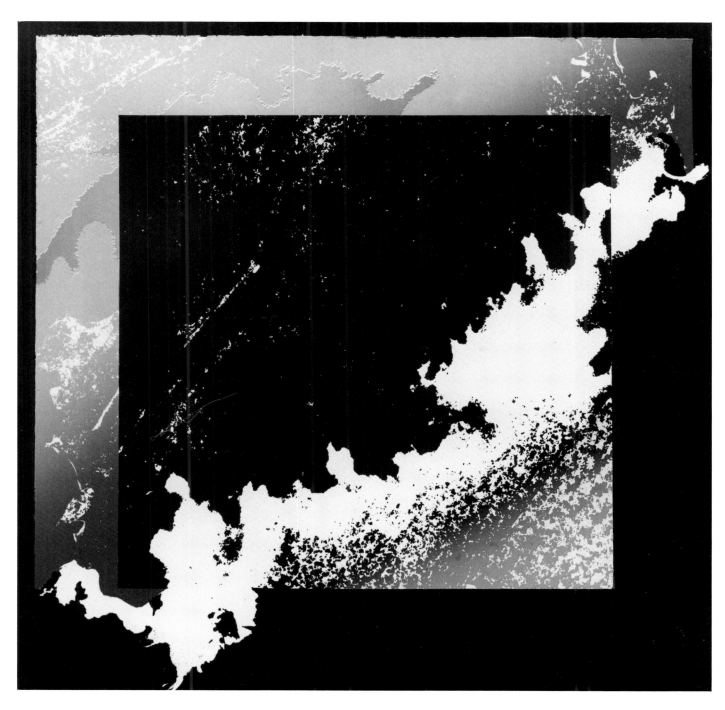

26. *Solar Wave*, 1981
 Lithograph
 Solar Flares Suite
 17¼ x 17 in.
 44 x 43 cm.
 Artist Proof B

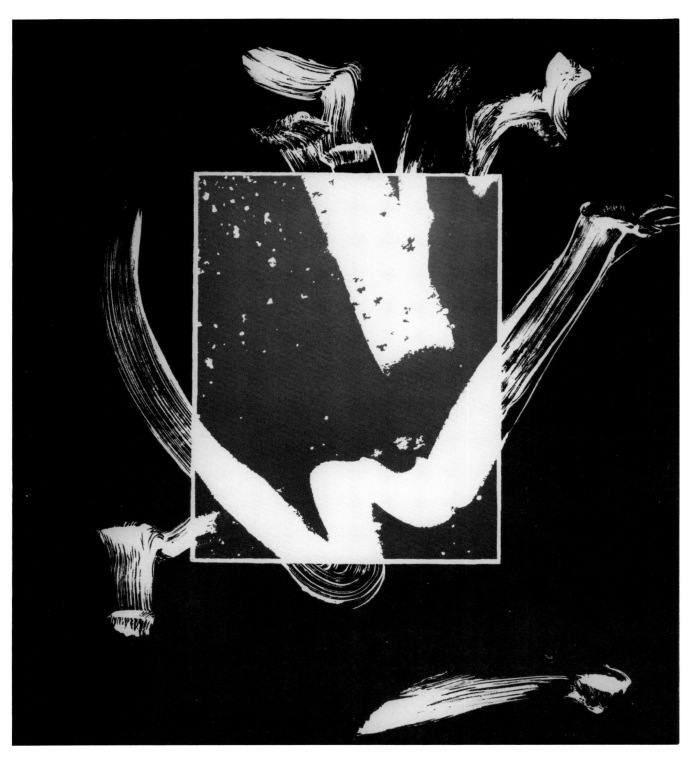

27. *Break Out*, 1986
Lithograph
25¾ x 20 in.
65½ x 51 cm.
Exhibition Proof II

28. *Chinook*, 1982
Lithograph
22½ x 24 in.
57 x 60½ cm.
Edition 20/20

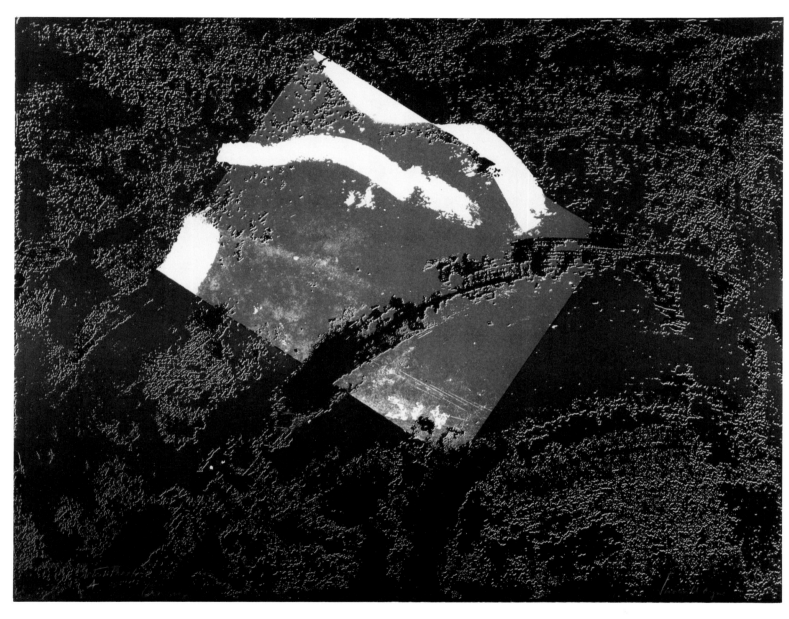

29. *Crossing*, 1986
Lithograph
4½ x 9½ in.
11½ x 24½ cm.
Exhibition Proof II

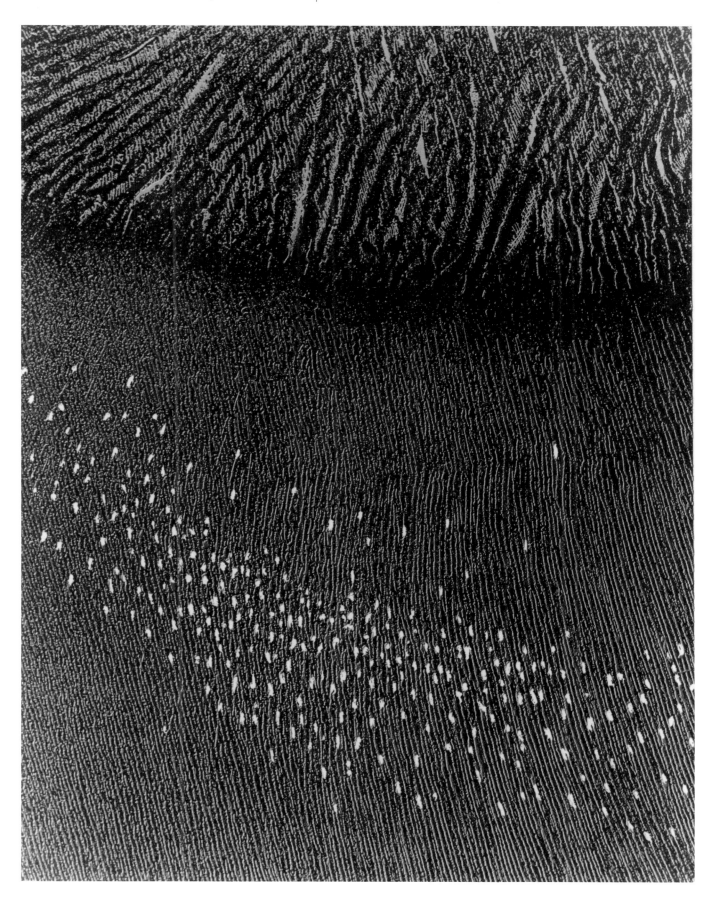

30. *Lodestar*, 1981
 Lithograph
 12¾ x 9¾ in.
 33 x 25 cm.
 Artist Proof B

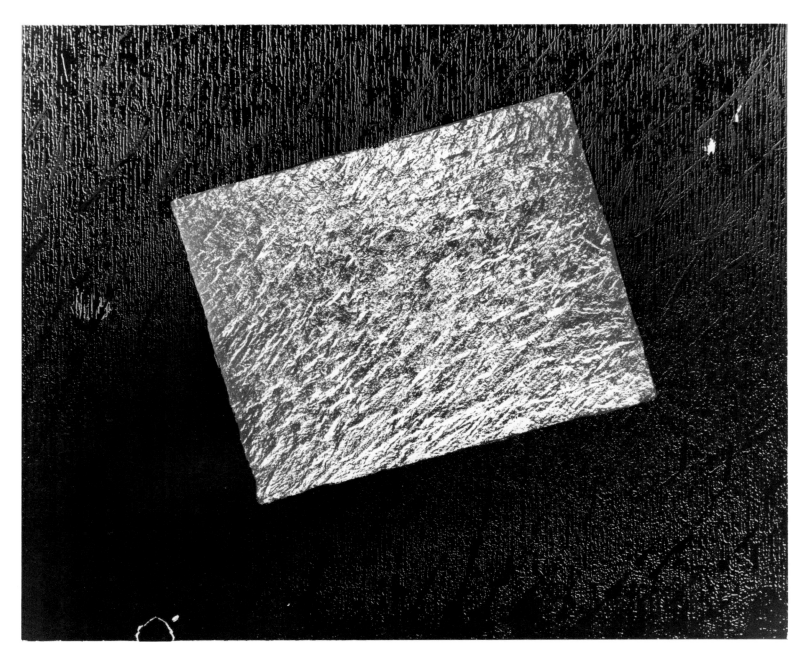

31. *Makari*, 1986
Lithograph
24 x 20 in.
61 x 51 cm.
Exhibition Proof I

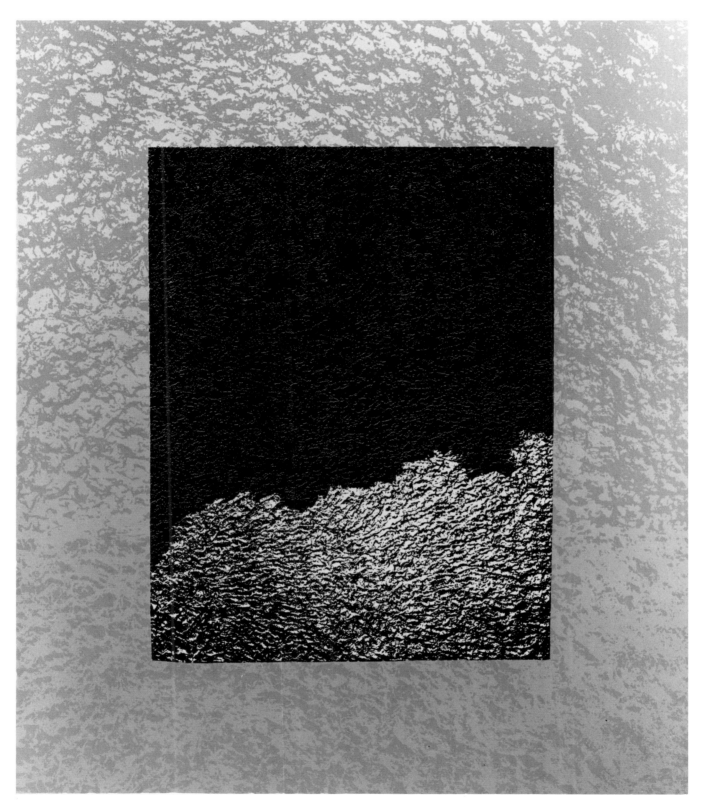

32. *No Sun*, 1985
Lithograph
24⅛ x 20⅛ in.
61 x 51 cm.
Exhibition Proof I

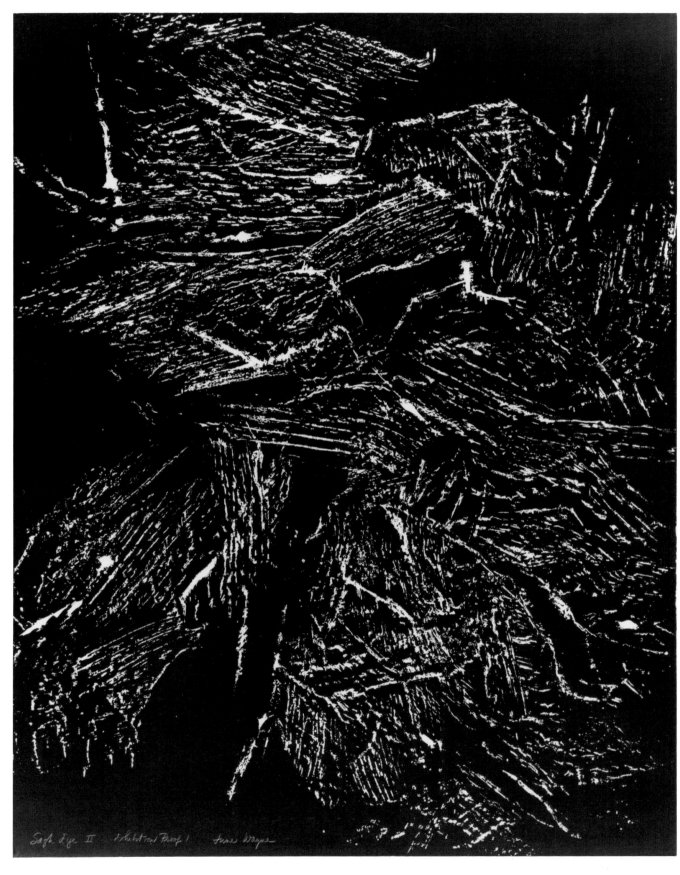

33.　*Sagh Eye II*, 1987
Lithograph
35 x 26¾ in.
89 x 67 cm.
Exhibition Proof II

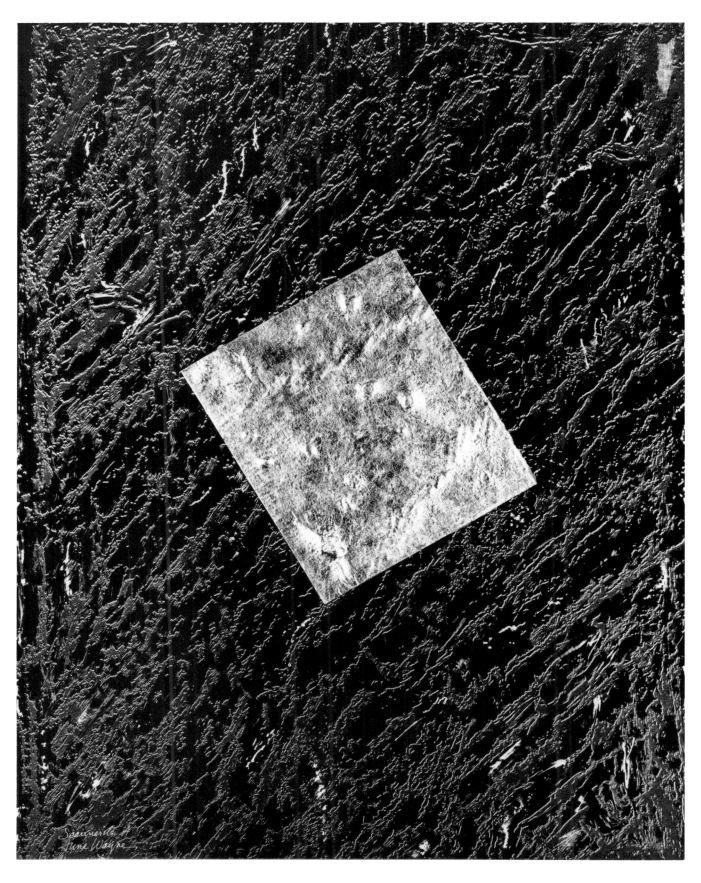

34. *Scannerite*, 1987
 Lithograph / Collage
 35 x 26¾ in.
 89 x 67 cm.
 Scannerite B

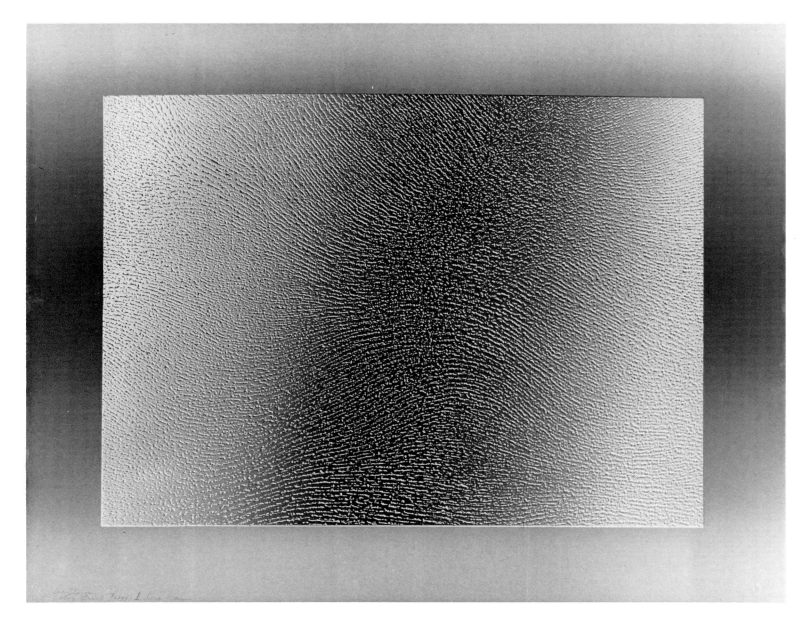

35. *Sea Change*, 1976
Lithograph
21 x 26½ in.
53½ x 67 cm.
Color Trial Proof I

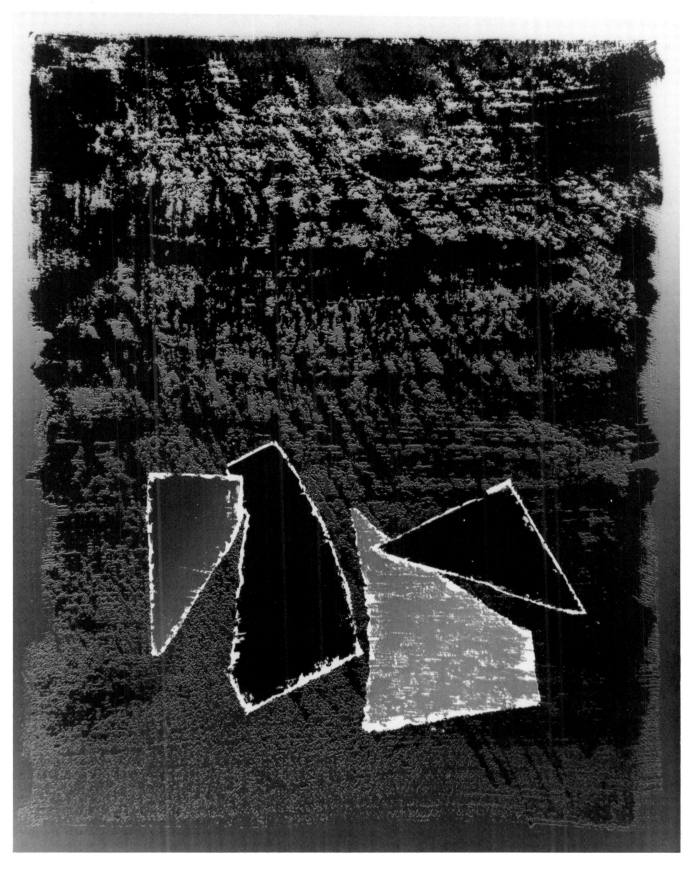

36. *Two Blacks*, 1987
 Lithograph
 27⅜ x 21 in.
 69½ x 53 cm.
 Exhibition Proof I

CHECKLIST TO THE EXHIBITION

All lithographs were hand pulled by Edward E. Hamilton, Tamarind Master Printer, in the artist's studio.

Astral Wave, 1978
Lithograph
Stellar Winds Suite
11⅛ x 9½ in.
28 x 24 cm.
Trial Proof 2

Astral Wave/White, 1978
Lithograph
Stellar Winds Suite
11⅛ x 9½ in.
28 x 24 cm.
Artist Proof F
Plate No. 11

Capella Wind, 1978
Lithograph
Stellar Winds Suite
11³/₁₆ x 9⁹/₁₆ in.
28 x 24½ cm.
Artist Proof A

Debristream, 1979
Lithograph
Stellar Winds Suite
11 x 9⅜ in.
28 x 23½ cm.
Artist Proof D
Plate No. 12

Double Current, 1978
Lithograph
Stellar Winds Suite
11 x 9⅜ in.
28 x 23½ cm.
Artist Proof D
Plate No. 13

Frothing, 1979
Lithograph
Stellar Winds Suite
11 x 9⅜ in.
28 x 23½ cm.
Artist Proof F
Plate No. 14

Magnawind, 1979
Lithograph
Stellar Winds Suite
11 x 9⅜ in.
28 x 23½ cm.
Artist Proof D

Scintillae, 1978
Lithograph
Stellar Winds Suite
11 x 9¼ in.
28 x 23½ cm.
Artist Proof H
Plate No. 15

Star Dust I, 1978
Lithograph
Stellar Winds Suite
11⅛ x 9⅜ in.
28 x 23½ cm.
Artist Proof C

Star Shower, 1979
Lithograph
Stellar Winds Suite
11 x 9⅜ in.
28 x 23½ cm.
Artist Proof C
Plate No. 16

Stellar Roil, 1978
Lithograph
Stellar Winds Suite
11 x 9¼ in.
28 x 23½ cm.
Artist Proof E
Plate No. 17

Velowind, 1980
Lithograph
Stellar Winds Suite
11 x 9⅜ in.
38 x 23½ cm.
Artist Proof F

Wind Veil, 1978
Lithograph
Stellar Winds Suite
11 x 9¼ in.
28 x 23½ cm.
Artist Proof F
Plate No. 18

Ablaze I, 1984
Lithograph
My Palomar Series
18½ x 16 in.
47 x 40½ cm.
Artist Proof D

Ablaze II, 1984
Lithograph
My Palomar Series
18½ x 16 in.
47 x 40½ cm.
Artist Proof B
Plate No. 19

Cool Take, 1984
Lithograph
My Palomar Series
18½ x 16 in.
47 x 40½ cm.
Artist Proof B
Plate No. 20

Earthscan, 1984
Lithograph
My Palomar Series
18½ x 16 in.
47 x 40½ cm.
Artist Proof F

Meridian II, 1985
Lithograph
My Palomar Series
18½ x 16 in.
47 x 40½ cm.
Artist Proof A
Plate No. 21

Night Field, 1984
Lithograph
My Palomar Series
18½ x 16 in.
47 x 40½ cm.
Artist Proof B
Plate No. 22

Over and Out, 1984
Lithograph
My Palomar Series
18½ x 16 in.
47 x 40½ cm.
Artist Proof B
Plate No. 23

Setsun, 1983
Lithograph
My Palomar Series
18½ x 16 in.
47 x 40½ cm.
Edition Artist Proof B
Plate No. 1

Solstice, 1984
Lithograph
My Palomar Series
18½ x 16 in.
47 x 40½ cm.
Artist Proof G
Plate No. 2

Twinight, 1983
Lithograph
My Palomar Series
18½ x 16 in.
47 x 40½ cm.
Artist Proof C
Plate No. 24

Solar Refraction, 1982
Lithograph
Solar Flares Suite
17¼ x 17 in.
44 x 43 cm.
Color Trial Proof 3
Plate No. 3

Solar Flame, 1981
Lithograph
Solar Flares Suite
16 x 16 in.
40½ x 40½ cm.
Artist Proof B
Plate No. 25

Solar Wave, 1981
Lithograph
Solar Flares Suite
17¼ x 17 in.
44 x 43 cm.
Artist Proof B
Plate No. 26

Solar Burst, 1981
Lithograph
Solar Flares Suite
16 x 16 in.
40½ x 40½ cm.
Artist Proof B

Ankidor, 1987
Lithograph
36¼ x 26¾ in.
91¼ x 68 cm.
Exhibition Proof II

Between I, 1983
Lithograph
18½ x 21½ in.
47 x 54½ cm.
Artist Proof D

Between II, 1983
Lithograph
18½ x 21½ in.
47 x 54½ cm.
Artist Proof A
Plate No. 4

Breeze, 1978
Lithograph
22¼ x 17¾ in.
56½ x 44½ cm.
Edition 15/16

Break Out, 1986
Lithograph
25¾ x 20 in.
65½ x 51 cm.
Exhibition Proof II
Plate No. 27

Chinook, 1982
Lithograph
22½ x 24 in.
57 x 60½ cm.
Edition 20/20
Plate No. 28

Code, 1982
Lithograph
20 x 21½ in.
50½ x 54½ cm.
Edition 15/15

Crossing, 1986
Lithograph
4½ x 9½ in.
11½ x 24½ cm.
Exhibition Proof II
Plate No. 29

Desert Wind, 1975
Lithograph
15½ x 12⅞ in.
39 x 32¾ cm.
Edition 3/20

Escape II, 1986
Lithograph
23½ x 24 in.
59 x 63½ cm.
Exhibition Proof II

Glitterwind, 1981
Lithograph
12⅞ x 9⅜ in.
32¾ x 24 cm.
Edition 10/10
Plate No. 5

Green Edge I, 1986
Lithograph
24¾ x 19 in.
62½ x 48 cm.
Exhibition Proof
Plate No. 6

Green Edge II, 1986
Lithograph
24¾ x 19 in.
62½ x 48 cm.
Artist Proof B

Lodestar, 1981
Lithograph
12¾ x 9¾ in.
33 x 25 cm.
Artist Proof B
Plate No. 30

Makari, 1986
Lithograph
24 x 20 in.
61 x 51 cm.
Exhibition Proof I
Plate No. 31

Myself, 1985
Lithograph
7 x 9 in.
18 x 23 cm.
Artist Proof C

No Sun, 1985
Lithograph
24⅛ x 20⅛ in.
61 x 51 cm.
Exhibition Proof I
Plate No. 32

Robagen, 1986
Lithograph
27¾ x 20⅛ in.
70 x 51 cm.
Artist Proof B

Saghex II, 1985
Lithograph
35 x 26¾ in.
89 x 67 cm.
Exhibition Proof II

Sagh Eye II, 1987
Lithograph
35 x 26¾ in.
89 x 67 cm.
Exhibition Proof II
Plate No. 33

Scannerite, 1987
Lithograph/Collage
35 x 26¾ in.
89 x 67 cm.
Scannerite B
Plate No. 34

Sea Change, 1976
Lithograph
21 x 26½ in.
53½ x 67 cm.
Color Trial Proof I
Plate No. 35

Silent Wind, 1975
Lithograph
24 x 34 in.
61 x 86½ cm.
Edition 1/13
From FAM Collection

Two Blacks, 1987
Lithograph
27⅜ x 21 in.
69½ x 53 cm.
Exhibition Proof I
Plate No. 36

Vio, 1987
Lithograph
17 x 12⅞ in.
45 x 33 cm.
Exhibition Proof II

Anki, 1984
Acrylic/silver leaf on canvas
72 x 54 in.
180 x 135 cm.

Ari, 1984
Acrylic/silver leaf on canvas
54 x 72 in.
135 x 180 cm.
Plate No. 7

Djuna, 1984
Acrylic on canvas
54 x 72 in.
135 x 180 cm.
Figure No. 1

Flor, 1984
Acrylic/silver leaf on canvas
30 x 20 in.
75 x 50 cm.

Hel, 1984
Acrylic on canvas
30 x 20 in.
75 x 20 cm.

Jev, 1984
Acrylic/gold leaf on canvas
30 x 20 in.
75 x 50 cm.

Khis, 1987
Acrylic/silver leaf on canvas
72 x 54 in.
180 x 135 cm.

Rhed, 1984
Acrylic on canvas
72 x 54 in.
180 x 135 cm.
Plate No. 8

Scanning AC, 1987
Acrylic on wood panel with silver
leaf collaged element
30 x 20 in.
75 x 50 cm.

Scanning GT, 1987
Acrylic on wood panel with silver
leaf collaged element
30 x 20 in.
75 x 50 cm.

Zhule, 1984
Acrylic on panel on canvas
and gessoed paper
40 x 30 in.
90 x 75 cm.
Plate No. 9

At Last a Thousand, 1971
Tapestry
7 x 9 ft.
2.23 x 2.84 m.

Lemmings Day, c. 1973
Tapestry
8 x 11½ ft.
2.85 x 2.35 m.

Onde en Folie, c. 1972
Tapestry
10 x 3 ft.
3.05 x 0.91 m.
Plate No. 10

The Target, 1971
Tapestry
8 x 6½ ft.
2.85 x 1.98 m.

Verdict, 1971
Tapestry
10 x 6½ ft.
3.05 x 1.98 m.
Figure No. 2

CHRONOLOGY
SELECTED EXHIBITIONS
AND HONORS

CHRONOLOGY

1918 Born Chicago, Illinois.
1933 Leaves school, starts supporting herself.
1934 Leaves home.
1935 Has first solo exhibition.
1936 Is invited by the Mexico Department of Public Education to come to Mexico to paint. Has an exhibition of paintings at the Palacio de Bellas Artes.
1937 Goes to work for Marshall Field and Company, Chicago, in its art galleries. Continues painting.
1938 Becomes an easel project artist, the WPA Art Project of Chicago.
1939 Becomes an industrial designer in New York, continues painting.
1941 Moves to California. Becomes certified as a production illustrator and also learns to write for radio.
1942 Goes to work for WGN in Chicago as a staff writer.
1945 The war ends. Returns to California, continuing to paint.
1948 Starts lithography, using Lynton Kistler as her printer.
1950 Starts an active public exhibition schedule in painting and in printmaking.
1949-56 Becomes interested in narrative as an esthetic; also optics; also symbol systems. Creates the Kafka Series, the Optics Series, the Fable Series, the Justice series—paintings and lithographs.
1955-56 Becomes a consultant to "You and Modern Art," a discussion series funded by the Fund for Adult Education of the Ford Foundation. Starts the John Donne Series.
1957 Goes to France. Makes John Donne images with Marcel Durassier as her lithograph printer.
1958 Acquires her Tamarind Avenue studio. Returns to France and creates "Songs and Sonets of John Donne," a livre d'artiste.
1959 Writes the plan for the Tamarind Lithography Workshop for the Ford Foundation.
1960-70 Founds and directs the Tamarind Lithography Workshop. Creates the Lemming Series and various individual works.
1969 The Art of June Wayne by Mary Baskett is published by Bruder Mann of Berlin and Harry Abrams Inc. of New York. Creates designs for tapestries. Prepares the transfer of Tamarind's activities to the University of New Mexico.
1970-74 Tamarind Institute is formed. Returns to her solo creative work. Starts collaboration with French tapestry weavers. Creates the Burning Helix and Tidal Waves series.
1972 Writes and hosts an eight-part television PBS series titled "June Wayne."
1973 Shows her post-Tamarind work at the Municipal Art Galleries of Los Angeles. Completes the film Four Stones for Kanemitsu.
1975-79 Creates The Dorothy Series. Has various shows in the United States and abroad.
1978-82 Creates the Stellar Winds Series. Also an audio-visual slide show for The Dorothy Series. Also television PBS program on The Dorothy Series.
1983-87 Creates the Cognitos paintings. Also My Palomar Solar Flares and the Sagh Series.

SELECTED SOLO EXHIBITIONS

1988 Fresno Art Museum, Fresno, California
 The Djuna Set
 Paintings, lithographs, collage, tapestries
 In 1989 The Djuna Set will travel.
1988 Murray Feldman Gallery, Pacific Design Center, Los Angeles, California
 My Wilderness: There from Here
 Paintings, prints, tapestries
1988 Associated American Artists Gallery, New York, New York
 There from Here: lithographs
1986 Macalester College Art Galleries, St. Paul, Minnesota
 My Palomar and Others: Prints and Tapestries
1985 Associated American Artists Gallery, New York, New York
 My Palomar and Beyond
1985 Galerie Des Femmes, Paris, France
 My Palomar and Stellar Winds
1985 Tobey Moss Gallery, Los Angeles, California
 A Day Off
 Lithographs
1984 Armstrong Gallery, New York, New York
 Cognitos
 Paintings
1983 Montgomery Art Museum, Pomona College, Pomona, California
 The Dorothy Series†
 Lithographs
1983 Tobey Moss Gallery, Los Angeles, California
 June Wayne: Before Tamarind
 Lithographs
1983 Historical Collection, North Denton University, Denton, Texas
 The Dorothy Series†
 Lithographs
1983 The San Jose Institute of Contemporary Art, San Jose, California
 Shortcuts, Feathers, Winds by June Wayne
 Miniature lithographs
1982 Visual Arts Gallery, University of Alabama, Birmingham, Alabama
 The Dorothy Series†
 Lithographs
1982 The Crocker Museum, Sacramento, California
 The Dorothy Series†
 Lithographs
1982 Des Moines Art Center, Des Moines, Iowa
 The Dorothy Series†
 Lithographs
1982 Sunset Cultural Center, Carmel, California
 The Dorothy Series†
 Lithographs
1982 The Grunwald Center for the Graphic Arts, Frederick S. Wight Gallery, University of California, Los Angeles, California
 The Dorothy Series†
 Lithographs
1982 The Jewish Museum, New York, New York
 The Dorothy Series†
 Lithographs

1974 Muckenthaler Cultural Center, Fullerton, California
Lithographs and Tapestries by June Wayne

1974 Van Doren Gallery, San Francisco, California
June Wayne: Tapestries, Paintings, Lithographs

1973 Municipal Art Gallery, Barnsdall Park, Los Angeles, California
June Wayne: Lithographs, Paintings, Tapestries

1972 Gimpel-Weitzenhoffer Gallery, New York, New York
The Burning Helix and Tidal Waves by June Wayne
Lithographs

1971 The Grunwald Center for the Graphic Arts, Frederick S. Wight Gallery, University of California, Los Angeles, California
The Burning Helix
Lithographs, tapestry cartoons

1971 Peter Plone Associates, Los Angeles, California
The Burning Helix Series (Realizing the Genetic Code)

1970 Iowa Art Museum, University of Iowa, Iowa City, Iowa
Forty Lithographs by June Wayne

1969 Cincinnati Art Museum, Cincinnati, Ohio
Lithographs by June Wayne: A Retrospective

1969 Far Gallery, New York, New York
Twenty Years of Wayne Lithographs

1968 The Art Museum, University of New Mexico, Albuquerque, New Mexico
Thirty Lithographs by June Wayne

1959 Philadelphia Art Alliance, Philadelphia, Pennsylvania
Lithographs by June Wayne including the John Donne series

1959 Long Beach Museum of Art, Long Beach, California
Paintings and Prints by June Wayne

1959 Los Angeles County Museum of Art, Los Angeles, California
The Songs and Sonets of John Donne by June Wayne

1958 TheSanta Barbara Museum of Art, Santa Barbara, California
Lithographs and Paintings by June Wayne

1958 The Achenbach Foundation for Graphic Arts, California Palace of the Legion of Honor, San Francisco, California
Lithographs by June Wayne

1956 M. H. De Young Museum of Art, San Francisco, California
The Messenger: A Painting and Forty Drawings and Print Studies for It

1954 The Art Museum of La Jolla, La Jolla, California
Paintings and Lithographs by June Wayne

1953 The Contemporaries Gallery, New York, New York

1953 The Santa Barbara Museum of Art, Santa Barbara, California

1952 The Art Institute of Chicago, Chicago, Illinois
Lithographs

1950 The San Francisco Museum of Art, Civic Center, San Francisco, California
Paintings by June Wayne

1950 The Santa Barbara Museum of Art, Santa Barbara, California
Prints and Paintings by June Wayne

1936 The Palacio de Bellas Artes, Mexico City, Mexico D.F.
Paintings by June Wayne

1935 Boulevard Gallery, Diana Court Bookshop Gallery, Chicago, Illinois

1981 San Diego Museum of Art, San Diego, California
The Dorothy Series†
Lithographs

1981 Las Vegas Charleston Heights Arts Center, Las Vegas, Nevada
The Dorothy Series†
Lithographs

1981 West Hills Community College, Coalinga, California
The Dorothy Series†
Lithographs

1981 Anita Seipp Gallery, Palo Alto, California
The Dorothy Series†
Lithographs

1980 Occidental College, Los Angeles, California
June Wayne: Before Cosmos
Paintings, lithographs

1979 Museum of Art, Lyon, France
June Wayne—Tapisseries, Lithographies

1979 Museum of Chartres, Chartres, France
June Wayne—Tapisseries, Lithographies

1979 Maison de la Culture, Andre Malraux, Reims, France
June Wayne—Tapisseries, Lithographies

1979 Fondation Pescatore, Luxembourg
June Wayne—Tapisseries, Lithographies

1979 Arizona State University, Tempe, Arizona
50 Works in 3 Media: June Wayne

1978 American Library and Cultural Center, Bruxelles, Belgium
Tapisseries et Lithographies de June Wayne

1978 Lang Gallery, Claremont Colleges, Claremont, California
50 Works in 3 Media: June Wayne

1977 Palm Springs Desert Museum, Palm Springs, California
June Wayne's Lithographs

1977 Les Premontres, Nancy, France
Lithographies, Tapisseries de Wayne

1977 Cypress College, Cypress, California
Tapestries and Lithographs

1977 Rubicon Gallery, Los Altos, California
Lithographs and Tapestries

1977 Musee Municipal, Brest, France
Lithographies et Tapisseries

1976 Franco American Institute, Rennes, France
Tapisseries, Lithographies de June Wayne

1976 Art '76, Basel, Switzerland (La Demeure, Paris, France)
Tapisseries, Lithographies de June Wayne

1976 Van Doren Gallery, San Francisco, California
Paintings and Tapestries of June Wayne

1976 Adams State College, Alamosa, Colorado
Winds, Waves and Visas by June Wayne

1976 University of Southern Colorado, Pueblo, Colorado
Winds, Waves and Visas by June Wayne

1976 University of Wisconsin, Oshkosh, Wisconsin
Winds, Waves and Visas by June Wayne

1975 Artemisia Gallery, Chicago, Illinois
Winds, Waves and Visas by June Wayne

1975 The First American Film Festival, Deauville, France
Tapisseries de June Wayne

1975 La Demeure Gallery, Paris, France
Tapisseries et Lithographies de June Wayne

†WAAM traveling show

SELECTED PUBLIC COLLECTIONS

The Adolph Foundation, Los Angeles, California
The Australian National Gallery, Canberra, Australia
Achenbach Foundation for the Graphic Arts, Palace of the Legion of Honor, San Francisco, California
Allen Art Museum, Oberlin College, Oberlin, Ohio
American Telephone and Telegraph Collection
Amon Carter Museum of Western Art, Fort Worth, Texas
The Art Institute of Chicago, Chicago, Illinois
Atlantic Richfield Collection, California
Bibliotheque Royale de Belgique, Bruxelles, Belgium
Bibliotheque Nationale de France, Paris, France
California State Colleges Collection
The Clark Library, Los Angeles, California
Columbia Museum of Art, Columbia, South Carolina
Depauw University, Greencastle, Indiana
Des Moines Art Center, Des Moines, Iowa
Fluor Corporation Collection, Irvine, California
Fresno Art Musuem, Fresno, California
The Martin and Enid Gleich Collection, San Diego, California
Great Western Savings and Loan Collection, California
Grunwald Center for the Graphic Arts, University of California, Los Angeles, California
The Houghton Library, Harvard, Cambridge, Massachusetts
The Huntington Art Gallery, University of Texas, Austin, Texas
La Jolla Museum of Art, La Jolla, California
The Ledler Foundation, Los Angeles, California
Lehigh University, Bethlehem, Pennsylvania
Le Musée D'Epinal, France
Le Musée de Saint Die, Saint Die, France
Library of Congress, Washington, D.C.
Long Beach Museum of Art, Long Beach, California
Los Angeles County Museum of Art, Los Angeles, California
Museum of Modern Art, New York, New York
National Gallery of Art, Rosenwald Collection, Washington, D.C.
Newberry Library, Chicago, Illinois
New York Public Library, New York, New York
New York Public Library Spencer Collection
O'Melveny and Meyers Collection, Los Angeles, California
Pasadena Museum of Modern Art, Pasadena, California
Lloyd Rigler Collection, Burbank, California
Philadelphia Museum of Art, Philadelphia, Pennsylvania
San Diego Musuem of Art, San Diego, California
San Jose State College, San Jose, California
Santa Barbara Museum of Art, Santa Barbara, California
Security Pacific National Bank Collection, Los Angeles, California
Smithsonian Institution, Washington, D.C.
University of California at Santa Barbara, Santa Barbara, California
University of Minnesota Library, Minneapolis, Minnesota
University of New Mexico Art Museum, Albuquerque, New Mexico
Walker Art Center, Minneapolis, Minnesota
Wilkie Foundaton, Des Plaines, Illinois
Williams College Museum of Art, Williamstown, Massachusetts

SELECTED TELEVISION AND FILM

1981 *The Dorothy Series* and *About The Dorothy Series*, a 17-minute video program created by June Wayne using images from her suite of the same name; plus an 11-minute interview with Wayne in her studio, discussing the making of the suite. Produced by Price Hicks for KCET-PBS. Directed by Bruce Franchini. Aired intermittently on PBS from 1981 to 1983.

1981 *Art Beat*. Nancy Kaufman, host. KRLU, Channel 18, Austin, Texas.

1981 *Art City*. A one-hour BBC/PBS-TV production, Michael Caine, narrator.

1979 *Once a Daughter*, a Lynn Littman Film. Five documentary segments of which one features June Wayne with reference to the making of The Dorothy Series.

1976 *The Creative Process*. Double X Production, 45-minute lecture by Wayne.

1973 *Four Stones for Kanemitsu*, a Tamarind Production, June Wayne, producer. 35 mm, 16 mm color, sound, 28 minutes.

1972 *The Lively Arts* with James Hanschumacher, host. Half-hour with June Wayne, produced by James Malthus for CBS.

1972-74 *June Wayne Series*, an eight-segment series for KCET/PBS, produced by Price Hicks, written and hosted by June Wayne. Videotaped in Wayne's studio with Francoise Gilot, Louise Nevelson, May-Natalie Tabak, Ti-Grace Atkinson, Grace Glueck, Barbaralee Diamonstein, Lorser Feitelson, Charles White, Ann McCoy. Aired nationally.

1970 *Speculation with Keith Berwick*. Conversation with June Wayne, produced by Price Hicks for KCET/NET.

1969 *The Look of a Lithographer*, a Tamarind Production. Directed by Jules Engel, photography and editing by Ivan Dryer, narration written by June Wayne. 16 mm, black and white, sound, 45 minutes.

SELECTED WRITINGS

"Making Art in the 1980s: A Hard Choice," ancillary to "Avant-garde Mindset in the Artist's Studio," 1987.

"The Visual Artist and the Galaxies," presented at WESTWEEK, Pacific Design Center, Los Angeles, 1986.

"Avant-garde Mindset in the Artist's Studio," 1985, written for presentation at Hofstra University in 1986; published in 1987.

"The View from Inside," extemporaneous speech on the 25th anniversary of Tamarind, 1984.

"The Creative Process: Artists, Carpenters and the Flat Earth Society." *Craft Horizons, Vol. XXXVI, No. 35, October 1976.*

"The Tradition of Narrative Tapestry." *Craft Horizons, Vol. XXXVI, No. 4, August 1974.*

"The Male Artist as Stereotypical Female." *College Art Journal*, Summer 1973. *Art News*, Vol. 72, No. 10, December 1973. *Art in Society*, Vol. II, No. 1, Spring-Summer 1974; also in various anthologies.

"On Defining an Original Print." *The Print Collector's Newsletter*, Vol. III.

Foreword to *Sex Differentials in Art Exhibition Reviews: A Statistical Study.* Tamarind Lithography Workshop, Inc., Los Angeles, 1972.

Preface to *The Tamarind Book of Lithography: Art and Technique.* Harry N. Abrams, Inc., 1971.

About Tamarind, a Tamarind Publication, 1969.

New Careers in the Arts, a Tamarind Publication, 1966.

Foundation Gamesmanship, a Tamarind Publication, 1966.